Hinsonville's
HEROES

Hinsonville's
HEROES

Black Civil War Soldiers of Chester County, Pennsylvania

Cheryl Renée Gooch, PhD

THE
History
PRESS

Published by The History Press
Charleston, SC
www.historypress.net

ISBN 978-1-5402-2815-4

Library of Congress Control Number: 2017958374

This book is dedicated to Hinsonville's heroes whose combat roles transformed them into agents of emancipation, and who continued the work of Chester County, Pennsylvania's early champions for civil rights.

Testimony to the martial valor of the negro soldier comes from the lips of friend and foe alike. He disappointed his enemies and surprised his friends.
—*George Washington Williams, 1887*

We Saved This Great Union for You

We're old, weary soldiers; our battles are over,
Our footsteps are feeble, we're nearing the shore;
We're slowly and surely approaching the crossing,
A little while longer and all will be o'er.
When my comrades and I pass through
The dark valley,
Will you still be faithful? Will you
Remain true?
When the graves mark the spot where
The soldiers are resting;
Remember! We saved this great Union for you!

Contents

Acknowledgements

A grateful beneficiary of many individuals who eagerly share their insights and resources to remember, interpret and teach the history and contributions of United States Colored Troops, I thank my colleagues at Camp William Penn Museum in historic La Mott, Pennsylvania, and Petersburg National Battlefield and Richmond National Battlefield Parks. Equally, efforts of the 54th Massachusetts Volunteer Infantry Regiment, Company B reenactors and the National Park Service to engage the public in this history through interpretation and research enrich understanding of our shared American history.

My heartfelt thanks to Hersey Gray Sr., great-great-grandson of William Walls and great-nephew of Albert G. Walls, with whom relatives meet each year at Hosanna AUMP Church to commune with the ancestors and launch the Walls Family Reunion. He has invited me for the last two years to share this evolving research.

And to the eighteen known USCT veterans and their families who recorded their experiences and erected monuments to help us remember their sacrifices to secure our civil rights while reforming our democracy, I pray these stories aptly show your role and place in American history.

"Slavery's Brutal Chain Shall Be Broken"

THE COLORED VOLUNTEERS—It is quite surprising with what alacrity the colored men are volunteering in the Army. Mr. Beugless has opened a paper in West Chester, and in two weeks he had nearly one hundred names. A short lusty young fellow called at the Record Office on Thursday last—said he had volunteered and had composed a few verses for his friends he should leave behind.[1]
—Village Record, *June 30, 1863*

West Chester, Pennsylvania. Since army captain Thomas Beugless opened his recruitment office at 30 Gay Street, black men from across Chester County had been arriving. Although by Pennsylvania militia laws they could not formally enlist in colored regiments for another three months, they hurried to volunteer, enticed by promised signing bonuses and a chance to fight for rights they hoped would be honored.

A "short lusty young fellow" caught the reporter's eyes and ears and everyone else's: Tillman Valentine Jr., a free man whose biracial bloodlines stretched through southeastern Chester County, Pennsylvania, and to neighboring New Castle County, Delaware. Tillman stood erect to recite his well-hewn words, soon to be committed to historical memory. Knowing his and their role in shaping America's future, he said what every free-born black man or former slave there was thinking:

Farewell, dear friends, we leave you now,
We are going to a country far;
We are going to meet the rebels,
And face the bloody war.

And if we ne'er return again,
May God protect you here;
Remember that we fought and fell
For the country we hold dear.

The day has come, the call is made,
Get ready for the war;
The men's gone out enrolled for draft;
They want some thousands more.

We believe the day has come
That slavery's brutal chain,
Shall be broken down,
And man shall stand with man.

We are going now, dear friends,
Farewell, to one and all,
And if we nevermore return,
We shall in battle fall.

If God intends us this,
It is to be our lot;
He can preserve us all,
Therefore I murmur not.

We hope he'll give us strength
To break the awful bar,
And subdue the rebel horde,
And stop this mighty war.[2]

Tillman's poetic words are a compelling firsthand account of ordinary black men's motivations for enlisting. He and these men were ready to fight and die for the country into which they were born, even though it denied them full rights of citizens. Whatever risks, they understood the

gains: "Slavery's brutal chain shall be broken down, and man shall stand with man."

Twenty-seven miles southwest of West Chester is the village of Hinsonville, where more than a dozen men whom Tillman knew were doing or preparing to do the same: enlist to preserve the Union. More than 150 years later, most will rest in a cemetery surrounding Hosanna AUMP (African Union Methodist Protestant) Church, which Tillman's family once attended. His father, Tillman Valentine Sr., was among the black pioneers to settle and own land in Hinsonville in the early 1800s, before relocating his family to West Chester. The Valentines are related by blood and marriage to the Fitzgerald and Walls families of Hinsonville.[3] The eloquent Tillman, whom the *Village Record* reporter could not ignore, was connected to a community whose residents shaped the history of Pennsylvania, the country and the world and were determined to be heard.

Named for Emory Hinson, a black man who purchased acres straddling Lower and Upper Oxford Townships, Hinsonville attracted both free and determined-to-be-free people who championed religious independence, higher education, landownership and equal rights. Residents organized a black Protestant church, supported the founding of Ashmun Institute (later Lincoln University), vigilantly opposed slavery and, in some cases, immigrated to Liberia as a part of the colonization movement. The community's tradition of self-determination compelled eighteen of its men to enlist to advance the freedom cause:

Samuel Henry Blake, 127th
Charles William Cole, 24th
James Cole, 54th Massachusetts
Josiah Cole, 54th Massachusetts
Amos Daws, 127th
George W. Duffy, 22nd
Robert G. Fitzgerald, 5th Massachusetts
William B. Fitzgerald, 41st
Hugh Hall, 25th
Isaac Amos Hollingsworth, 127th
George Jay, 54th Massachusetts
Wesley Jay, 54th Massachusetts
William Jay, 54th Massachusetts
Lewis Palmer, 25th
Stephen J. Ringgold, 22nd

Lewis W. Ringold, 25th
Abraham Stout, 41st
Albert G. Walls, 54th Massachusetts

Tillman served in the 3rd USCT, the first regiment to train at Camp William Penn, established near Philadelphia for black troops. He settled in Jacksonville, Florida, after the war, where he was a leader in the Grand Army of the Republic (GAR) fraternity. Ten of his comrades, neighbors and relatives are buried at Hosanna on land Edward Walls donated.[4] His nephew Albert G. Walls was the first of two known casualties among the village's men who enlisted to break "slavery's brutal chain." Albert's brother-in-law Hugh Hall was the second. Their cousins and neighbors made it back home alive, if not always well. All suffered for the rest of their lives with disabilities and illnesses incurred during army service.

The enlistees' social backgrounds varied. Some had benefitted from formal education; some were illiterate. Some were born into slavery, some free born to formerly enslaved parents. Before enlisting, most appear to have been living as free men in or near Hinsonville. Yet despite their status, they could not vote and faced discriminatory laws and practices that limited their social mobility and employment—even their personal safety could be tenuous. The Fugitive Slave Act of 1850 and abductions of blacks meant that free or not—they lived within several miles of the state line of Maryland, which enforced the act—they could be stolen and sold into slavery.

With racial prejudice permeating most aspects of their lives and social relations with the predominately white communities surrounding them, Hinsonville residents forged a delicate, trusting relationship with Ashmun co-founder Presbyterian minister John Miller Dickey, who in 1854 chose their tranquil haven for a school to provide black men access to higher education. Ironically, while being a target of intolerant sectors of Oxford's community for opening such a school, Dickey harbored an ingrained prejudice toward blacks. The son of Ebenezer Dickey, a slave owner, Reverend Dickey lauded the village's stability and industrious residents yet favored sending blacks (free and freed) to Liberia instead of immediately abolishing slavery and integrating blacks into American society. Like many of his nineteenth-century clergy peers who supported Liberian colonization, Dickey saw slavery as part of God's plan to Christianize and enlighten black people. Ashmun would train black ministers to convert heathen Africans while uplifting them from barbarism with Euro-American values.[5] In the following decades, as students and alumni protested the school's refusal to hire black professors, Dickey

maintained that whites were best qualified to teach blacks, who needed time to evolve intellectually and socially.[6] The institution later renamed to honor President Abraham Lincoln, who issued the Emancipation Proclamation freeing slaves in states in rebellion and signed into law the United States Colored Troops—which motivated Hinsonville men to join the Union cause—would not hire a black professor until 1932.[7]

The church and cemetery within yards of Lincoln's front archway along Baltimore Pike are surviving monuments of a community whose residents witnessed the founding and supported the growth of the country's first degree-granting institution for blacks. Built in 1843, Hosanna was the village's spiritual and social center long before Ashmun accepted its first students, brothers James and Thomas Amos, who immigrated to Liberia after graduating, along with Samuel Glasgow and his family, all dedicated church members.[8]

Not highly educated men like their veteran counterparts who enrolled at the university, Hinsonville veterans (and their families) were determined to leave their mark, seeming to predict that historical accounts of the Civil War would mostly omit details of their involvement and sacrifices. Ten of the eighteen veterans chose to be buried at the historic Hosanna Church, whose members sheltered freedom seekers, hosted abolitionist meetings and sold land to and worked for the university that gradually redefined the village's identity. By 1869, Lincoln had expanded and absorbed most of the quiet farming village, which consisted of dozens of close-knit families, into the campus. Following the war, as the nearby industrial Lincoln Village emerged and the U.S. Post Office opened a branch near the train station bearing the same name, the pioneer enclave was soon overshadowed. But these intentionally placed headstones ensure that Hinsonville's men of valor are remembered. Displaying their full names, birth and death dates and regiment units, the weatherworn monuments provide tantalizing hints of even more details of their lives divulged in pension files.

The files provide the men's physical descriptions, occupations, health issues, personal habits, family and neighbor relationships, birth places and marriage dates, along with insightful details about the discriminatory conditions and practices they faced in attempting to secure equitable benefits, a largely overlooked aspect of black Civil War veterans' experiences. But black leaders convened state and national conventions to discuss veterans' grievances of not receiving sufficient pension benefits to cover their medical and living expenses. An 1867 convention held in Philadelphia formally demanded for black soldiers and sailors "equality of rights with white soldiers

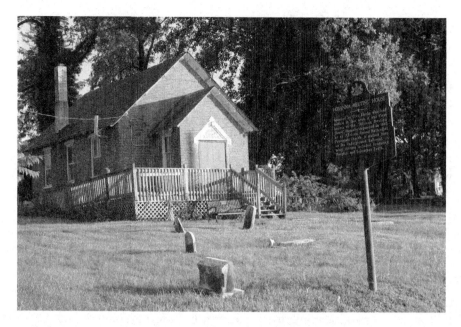

Hosanna Church and Cemetery. Hosanna's members supported the abolition of slavery. Ten of Hinsonville's eighteen USCT veterans are buried here. *André Warner.*

who also fought against the armed traitors to the American flag."[9] Over the years, most of Hinsonville's veterans lived in or near abject poverty as their declining health limited their ability to work. As they tried securing initial or increased pensions, civil rights leader Frederick Douglass in 1883 urged Congress to lift restrictive filing limits, noting, "Many of the soldiers and sailors that served in the war of the rebellion and their heirs, and especially colored claimants living in parts of the country where they have but meagre means of information, have been and still are ignorant of their rights and the methods of enforcing them."[10]

Hinsonville men had relationships with the university that ranged from intimate to cordial. In 1860, farm laborers Lewis Ringold and Stephen Ringgold were housemates of several Ashmun students, including Christian Fleetwood, who served in the 4th USCT and received the Congressional Medal of Honor for his heroic actions at the high-casualty Battle of Chaffin's Farm, New Market Heights, Virginia, in 1864. Christian and his classmates taught Bible classes at Hosanna and attended worship services and popular revivals held there.[11] His friend Robert G. Fitzgerald, who was born in Wilmington, Delaware, grew up in the village and enrolled at Ashmun before and after the war. Robert's detailed diary and correspondence with Lincoln president

Isaac Rendall shows how the institution inspired this former soldier to build and teach in freedmen schools in Virginia and North Carolina. University trustee and Presbyterian minister Robert P. DuBois officiated the marriage of Amos Hollingsworth and Mary Jane Harris in 1869. Lincoln theology professor George Carr officiated Charles William Cole and Bertha Lee's 1905 marriage, which likely took place on campus at Mary Dod Brown Chapel, which is still a favored wedding site.

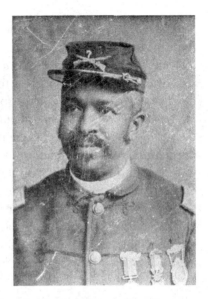

Ashmun student Christian A. Fleetwood roomed with future soldiers from Hinsonville and taught Sabbath school at Hosanna. Robert Fitzgerald was his classmate. *Library of Congress.*

Of Hosanna's ten documented Civil War burials, eight are still visible and decorated with GAR medallions and U.S. flags. Eight Hinsonville war heroes are buried elsewhere. Albert Walls's body was never found after the 54th's high-casualty battle with Confederates on James Island, near Charleston, South Carolina, in 1863. His brother-in-law Hugh Hall died from wounds in 1864 and is buried at the Barrancas National Cemetery in Pensacola, Florida. Their Walls descendants have placed a memorial headstone honoring them both in Hosanna's cemetery. Brothers James and Josiah Cole—first cousins to Albert Walls and the three Jay brothers, Wesley, William and George—are buried in Chester County cemeteries, James at Union Hill in Kennett Square and Josiah at Bethel AME (African Methodist Episcopal) Church in Downingtown. George Jay is buried in an unidentifiable plot in the former Embreeville Hospital cemetery in West Bradford, where he spent nearly thirty years institutionalized for mental illness. Stephen Ringgold, whose mother was a member of the Jay family, is buried in the former Mount Calvary AME Church Cemetery (now Allen AME) at Oxford's western edge.[12] Robert G. Fitzgerald, Tillman Valentine's first cousin, rests in the family cemetery in Durham, North Carolina, where most of the Fitzgerald clan relocated in 1868. His estranged brother William B. Fitzgerald returned to Pennsylvania and was buried in 1893 in Philadelphia's historically black Lebanon Cemetery, which was relocated later to the Eden Cemetery, established for blacks outside of the city in Collingdale.

First-person accounts contained in pension files provide insights about these nearly forgotten men's personalities and how war-related illnesses affected their lives, as well as the migration patterns and labor practices that determined where and how they lived. Census records, city directories, newspaper articles and diverse sources, including letters, Chester County Poorhouse reports, a soldier's detailed diary and even the penitentiary and mental institution records of one troubled veteran, enrich our awareness of unexplored lives of ordinary residents of southeastern Chester County who were involved in and shaped the history of Pennsylvania and the United States. West Chester resident John W. Brown, who enlisted in 1863 at the same recruiting office as Tillman Valentine to serve in the 6th USCT, also understood his role in ending slavery and obtaining rights for his race. "I left West Chester to enlist in the army to fight for my country, freedom and liberty," said the twenty-three-year-old brick maker.[13] So did Hinsonville's eighteen volunteers. Robert G. Fitzgerald proudly described his unit capturing Rebels in Virginia and freeing slaves from plantations there. His brother William B. Fitzgerald, Abraham Stout, Samuel H. Blake and Isaac A. Hollingsworth were on duty on April 9, 1865, at Appomattox, Virginia, when General Robert E. Lee surrendered, fulfilling their roles in ending the war and breaking "slavery's brutal chain." George W. Duffy and Stephen J. Ringgold's regiment led President Abraham Lincoln's funeral procession from the White House to the U.S. Capitol rotunda, a vivid display of freedom's ultimate cost and the involvement of Hinsonville men to secure it.

1

Sons of Pioneers and Firsts to Enlist

Two days after President Abraham Lincoln's Executive Order and Emancipation Proclamation to end the rebellion and slavery were issued, the African Methodist Episcopal Church–sponsored *Christian Recorder* printed a Presbyterian minister's sermon that resonated across denominational communities throughout the country. The unidentified minister's sermon, "What Is God's Will in Regard to Terms and Means of Peace?" posed and answered questions on many people's minds: *What is God's hand in all of this? What can we do?* "Whenever we can ascertain what God would have us do, we should perform it," the minister exhorted. "We are his servants."

Asserting that a peaceful American Union could not be achieved while slavery existed, the minister drew from biblical themes of bondage, delivery and chastisement familiar to nineteenth-century Christians, free, enslaved, black, white:

> *God has a controversy with this nation. He is chastising us severely, by civil war. God has four millions [sic] of human beings in our land, who are held in bondage by their brethren; oppressed, deprived of some of the dearest rights of man, enslaved, their children enslaved, they are groaning in their bondage, they are crying for deliverance. What would God do for these people? We learn his will by his Word, his Spirit, and his Providences. He makes us willing—by instruction and chastisements. He*

controls us by thwarting our plans which may be contrary to his, and by closing up all ways against us, but the one in which he would have us go.[14]

"What is God's Will?" echoed from the Philadelphia congregation where it was delivered to communities throughout the state. Congregants at Hosanna were calling and responding to the same issues: bondage, freedom, war and weighing the costs. Conversations flowed into their homes and gathering places. A part of the black AME circuit since the 1840s, Hosanna's members had been organized much longer as an independent faith community to support free and landowning families. They helped fugitive slaves, hosted abolition and colonization meetings for those choosing to seek their social and economic freedom in Liberia and cooperated with Ashmun, which shared their belief that higher learning was crucial to black people's salvation. Upon hearing the call to serve their country and free those denied these same rights, the sons of the village's pioneers were the first to act.

By mid-March, Albert G. Walls; William, Wesley and George Jay; and James and Josiah Cole had enlisted in Company B of the 54th Massachusetts and were heading to Readville, Massachusetts. All first cousins, they were sons of the children of patriarch Patrick Walls and his wife, Rachel, the matriarch who shared her name with her daughter, two daughters-in-law and a host of granddaughters and great-granddaughters. Walls naming traditions somewhat mirrored the family's migratory routes and marriages. The Wallses, Jays and Coles had formed the nucleus of Hinsonville since Patrick's sons Edward, William and George arrived in the late 1820s and early 1830s to buy and settle land. The Wallses came from an area between Darlington and Havre de Grace in Harford County, Maryland, where most of them had been freed before 1800.[15] James Cole and Joshua Jay, also of the area, joined them and married Rachel and Lydia, daughters of Patrick and Rachel Walls, respectively. The six cousins, whose families were anchored in the soil considered sacred, to which they all planned to return after military service, exuded the pride of free men accustomed to shaping their own destinies. They made up their minds: God had a plan, and they were God's soldiers.

True to their pioneer ethic, the cousins ventured ahead of the July 1863 General Order authorizing the creation of United States Colored Troops to enlist in the 54th Massachusetts, which began forming in January with mostly free men like themselves. In February, they were among the men recruited in Philadelphia who formed the major part of Company B. "Recruiting there

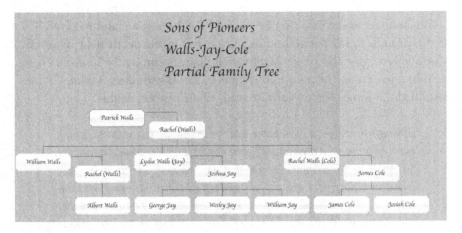

Sons of Pioneers
Walls-Jay-Cole
Partial Family Tree

Patrick Walls
Rachel (Walls)

William Walls
Rachel (Walls)

Lydia Walls (Jay)
Joshua Jay

Rachel Walls (Cole)
James Cole

Albert Walls | George Jay | Wesley Jay | William Jay | James Cole | Josiah Cole

Sons of pioneers Albert Walls; William, Wesley and George Jay; and James and Josiah Cole were grandsons of Patrick and Rachel Walls, Hinsonville's early settlers. *André Warner.*

was attended with much annoyance," a commanding officer recalled, partly because of hostile whites, and "the gathering place had to be kept secret, and the men sent to Massachusetts in small parties to avoid molestation or excitement."[16] The recruiting officer even had to purchase the train tickets himself and get "the recruits one at a time on the cars or under cover of darkness."[17] Undaunted, Albert, William, Wesley, George, James and Josiah were now key players in a cause to alter America's history. Nothing would deter them.

ALBERT G. WALLS

"Missing and Supposed Killed"

Sol Legare Island, near Charleston, South Carolina—The memorial marker on Sol Legare (pronounced *sawl la-gree*) recalls the bravery of the 54th's men who fought their first skirmish against Rebels who launched a night attack on July 16, 1863. It was a high-loss encounter for the regiment. Seventeen men were wounded, fourteen killed and twelve never found. Albert G. Walls lies among those missing in this marshy barrier island between James and Folly Islands about seven miles south of Charleston. Today, this serene enclave has a James Island zip code.

Four months and a day after he enlisted for three years and received $50 of the promised $325 state bounty, Albert fell to his death near here. His comrade George E. Stephens of Philadelphia was among the last soldiers to see him alive. In one of a series of letters to the *Weekly Anglo-African*, George described the James Island skirmish and Albert's probable fate:

> *Although there were a great many other troops on the Island, none but the black regiment of Massachusetts fired a gun. The 54th stood between the foes and our white comrades. On that day many of the wounded were killed, and Sergeant Vogelsang was pursued and shot like many others on the banks of an adjoining creek, which is very marshy. The only way that we could secure their bodies after the fight was by boat up the creek. Many of our wounded were shot while lying on the ground. Albert Walls, one of the missing or killed, did not hear the order to fall back and remained at his post and fought until killed or taken prisoner!*[18]

Today, residents and visitors recall the sacrifice and bravery of the 54th with a monument honoring the men who "gave their lives to win the freedom of enslaved Africans who were held in bondage here and on plantations throughout the south." A Gullah community, Sol Legare's residents descend from emancipated people who began settling here after the Civil War and retain linguistic and cultural traditions of their African ancestors. The often-cited biblical verse about spiritual warfare, Ephesians 6:13, "Therefore, take up the full armor of God, so that you will be able to resist in the evil day, and having done everything, to stand firm," has a Gullah translation familiar to people living in and near Sol Legare:

> *So den, oona mus pit on all dat God got fa protec oona een de fight, so dat wen de day come dat ebil come ta oona fa true, oona gwine be able fa stanop an fight ginst all de ebil scheme ob de Debil. An long as de enemy come ginst oona, oona gwine keep on da fight um. Oona gwine still stanop ginst um.*[19]

Their lineage reaching back several generations, Sol Legare's residents are firmly attached to their homesteads here, something to which Albert, a son of Hinsonville pioneers, would have related.

Born around 1834, Albert was the eldest of William and Rachel Walls's seven children. His brothers were George, Charles and William, names that recur generations later; his sisters were Sarah, Susanna and Mary. In 1850, the three-generation William Walls household included his father, Patrick,

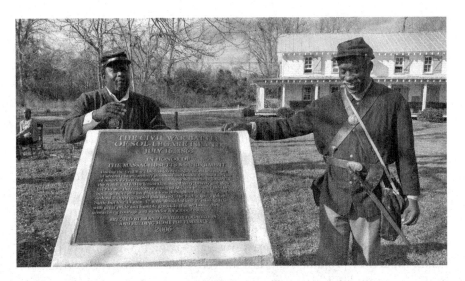

54th Massachusetts reenactors at Island Heritage Foundation Monument in Sol Legare, James Island, Charleston, South Carolina. Albert Walls died nearby. His body was never found. *Author's collection.*

who along with planning the family's move from Harford County arranged his children's marriages. Said to have been literate, William served as one of Hosanna's preachers and owned a ten-acre farm in Lower Oxford. But the family fell on hard times in 1854 after he died, and by 1860, Albert was working as a laborer and living with his sister Sarah and brother-in-law Hugh Hall and their children.

Albert, twenty-nine and single, was noted in Company B's descriptive book as standing six feet with a light complexion and brown eyes and black hair. He resembled many of his free-born Company B comrades, whom the white commanding officers, preoccupied with the enlistees' physical features, described as "comparatively light-complexioned" and taller than the former slaves who enlisted.[20] The cryptic summary of Albert's four months of service reads, "Missing and supposed killed in action on James Island, July 16, 1863. Never paid." Albert's remaining pay due from enrollment was likely sent to his family.

The first of the sons of Hinsonville pioneers to die for the Union, Albert is the most remembered by living history. Beginning with his brother George, who named one of his sons Albert, almost every generation of Walls since then has named a newborn child Albert.

WILLIAM JAY

"3 Acres of Good Land, with Good Buildings"

The historic Red Rose Inn at the intersection of Baltimore Pike and State Road 796 in Jennersville is haunted. Locals and paranormal investigators agree that at least two mournful souls linger around the inn, which opened around 1730 to serve travelers along what eventually became U.S. Route 1. Red Rose's ghosts are the innkeeper's daughter and the Lenape Indian man falsely accused of murdering her. The Lenape man often visited the inn, which was built along a trading road his people used centuries before William Penn's land grant gave it to white settlers. He befriended the girl and her family and on the day of the murder was seen giving her a strand of colored beads. Stoked by prejudice and lust for vengeance, locals lynched the man near the inn on land his Lenape ancestors used for centuries before white settlers arrived to claim it and his life. The vigilantes soon discovered the real murderer, someone who looked more like them than the corpse hanging from the tree, drunk in the woods behind the inn. Hastily, they wrapped their victim's body in a sheet and buried him nearby.[21] The carefully preserved Red Rose Inn today evokes within passersby nostalgia for the former pioneer community that grew up around it. That nostalgia belies the solemn energy created by the long-ago crime that some can still sense.

The community at these crossroads burgeoned into the village of Jennersville, including a general store and post office by the time William's parents, Joshua and Lydia Jay, settled their family in nearby Hinsonville. William owned a comfortable, newly built, two-story, six-room cottage situated on three acres of land, a short wagon ride from the Red Rose. The story of ghosts at the inn he passed often when picking up his mail from the post office was a dormant memory. In December 1892, three days after Christmas, a more tangible ghost haunted the former soldier: his impending death.

"The doctors can't cure me and I can't work and fear I am not long for this world," William Jay told Theodore Stubbs, the Oxford-based attorney who filed an increase request to the Pension Bureau on his behalf.[22] Two years beyond his fiftieth birthday, William weighed a mere 130 pounds—80 pounds less than when he enlisted in the army and was injured and permanently disabled. His body was wasting away. He knew his time was short and wrote to the bureau, "I am not so uneasy about my pension now as I am about myself, but wish you would hurry this up so I can use part

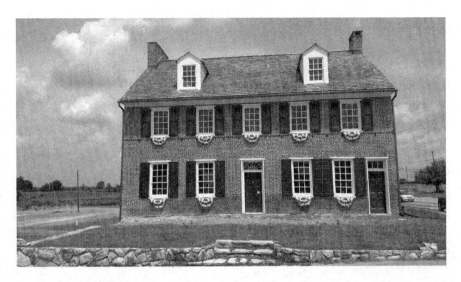

Red Rose Inn near William Jay's former three-acre farm in Jennersville. A Lenape man's ghost is said to haunt the popular landmark. *Author's collection.*

of it myself." Over the last twenty-seven years, the bureau had doled out meager payments, augmenting his income from farm labor, which he was increasingly unable to perform.[23]

William was discharged with disability on August 19, 1865, having been shot in the right elbow and hand during a battle at Boykin's Mill, South Carolina, in March earlier that year. Treated at military hospitals in Charleston and Beaufort and later in New York Harbor, William's three-dollar monthly disability payment began the day after his discharge—hardly an adequate amount to support a farm laborer with limited use of his right arm. William filed for increases in 1866, 1879, 1881, 1885, 1888, 1889, 1890 and 1892, a year before his death, when he began receiving twelve dollars.

The first of the Hinsonville veterans to receive a modest pension, William's struggles with disability and near destitution due to inability to work full time mirrored his comrades' woes. In 1875, surgeons examining the six-foot, 170-pound thirty-year-old recommended an increase, noting that his "wound through the right arm two inches above the elbow joint" had "disabled the use of his arm to some extent" and that "grape shot wound through his right hand at the joint of the second finger" had stiffened the finger, prohibiting him from closing his hand.[24] But no increase was approved. Four years later, he requested an increase with a supporting surgeon's report describing the worsening condition of his right arm, but an

increase to four dollars did not occur until 1881. William's attorney's filing four years later due to his client's "wound becoming more and more painful and loss of power in arm" and making it necessary for him "to get people to button his shirt" depicted the unyielding pain and difficulty of William's daily life but yielded no additional compensation.[25]

Between his 1865 discharge and 1885, major events in William's life included marriage, the death of a son, a purchase of three acres of land and a modest house, the death of his first wife and a second marriage. In 1870, William, his wife, Mary, and young son Harry lived next door to William's parents and younger siblings in Upper Oxford. While the young family gained its footing, William worked as a farmer and eventually fathered four more children: Carrie, Willie, Samuel and Maggie. Then on May 19, 1879, a dreadful tragedy befell William and Mary: they lost Harry, their firstborn, to tetanus:

Death from Lock-Jaw—A son of Wm. Jay, of Penn township, ran a thorn into his foot a short time since, and the wound festered. On Sunday, he was taken with convulsions, and the fester was opened and a piece of thorn removed, but the lad died on Monday morning. May 24, 1879[26]

Another tragedy struck the family when Mary died on August 4, 1883, leaving William to raise their four children. He recovered and married Charlotte Watson, a divorcée, in April 1885. While the Jay and Watson families likely hosted a ceremony for the couple, William and Charlotte exchanged vows in a practical setting. Justice of the Peace Andrew Shellady conducted the marriage of "Mr. William Jay of Penn township and Miss Charlotte Watson of London Grove township" on April 9, a Thursday.[27] That year, or earlier, the family suffered another loss when patriarch Joshua Jay died. As he left no will, his property eventually passed to William, his eldest son.[28]

William was receiving six dollars per month by 1888 and filed for another increase. By this time he was represented by a Washington, D.C.–based attorney who specialized in helping veterans take full advantage of changing pension laws. William's signed statement reads as follows:

Believes he is entitled to an increase due to the many liberal Acts of Congress increasing the rates of all classes of disabilities and the recent humane ruling of the Pension Bureau. Re-rating from discharge is claimed because the Pension Bureau originally allowed was unjustly low, and less than the

usual rating for such disabilities. He believes himself entitled to $6.00 from discharge and $10.00 now. William X Jay[29]

William's attached statement committed to public record how the former soldier who gallantly served with the famed Colonel Robert Gould Shaw's famed 54th coped with living in pain from day to day: "My arm so that it disables me from the full use of it in cutting wood or any other work that depends on the use of my arm…my arm contracts and gives me pain up to my shoulder and at times disables me."[30]

Stephen Ringgold, who served in the 22nd, likely a cousin, was one of many in the community who observed William's suffering. He backed up William's testimony and signed his full name, Stephen J. Ringgold, to the statement.[31]

Despite his disability, William, described as "a free man of color who was never a slave," held forth. His well-cultivated three-acre farm fed his family; their diet was supplemented with apples, peaches, pears and cherries from trees spread over the property. But poor health soon overtook the determined veteran, who served for two and a half years. The public sale notice of the property following his May 15, 1893 death detailed the hard-earned but soon-to-be-lost gains of his labor:

3 acres of good land, with good buildings, late the property of William Jay, deceased. The tract of land is on the road leading from Jennersville to Oxford, less than one mile from Jennersville, bounded by lands of Isaac P. Jackson, Frank Webster and Jane Armstrong. The new cottage style dwelling, 16 X 24 feet, has two stories and plastered attic, contains six rooms, with shed kitchen attached, good cellar, porch full front of dwelling, and good water near the door. Frame stable 16 X 18 feet, with wagon house and attached chicken house, hog house and other out buildings….This property was fitted up for a comfortable home, is one mile from Elkview station, on the Central Division on P.W. & B. R.R., and about the same distance from Kelton, formerly Penn Station. Persons desiring further information will please correspond with the Executer, at Lincoln University P.O. Sale to commerce at 1 o'clock p.m. Conditions made known at sale by John H. Lee, Executor. Oxford Press, November 30, 1893

Executor John H. Lee was married to Mary Cole, William's first cousin. Literate and thorough, John was also William's most trusted friend. He helped write William's will, which directed that he "be decently interred

in the church yard at Lincoln" and that all his "debts and funeral expenses be paid" by his cousin-in-law.[32] In regards to his second wife, stepchildren and, perhaps, marital tensions, William directed that "my wife Charlotte Jay...hold possession of the house and lot of land until my youngest child becomes of age; provided that she remains my widow and keeps a home for my children."[33] If Charlotte remarried, the property would be put up for sale, and she would receive a third of the proceeds, the remainder divided evenly between Maggie and Walter, children born to William and his first wife, Mary. Their other children, Carrie, Willie and Samuel, were not mentioned.

At first, Charlotte said she wanted to keep the house she and William shared for eight years with her stepchildren, but only if it appraised at $300 and could be divided evenly, without loss. Soon, though, she learned that there was an outstanding $600 mortgage with the Building Association of London Grove, and an ordered inventory of household items amounted to only $210.35. William's personal property was insufficient to pay the mortgage and his debts, leaving Charlotte in an unstable situation. She abandoned the house, refusing to return.

Despite this, she began receiving a widow's pension of eight dollars per month fourteen days after William's death. William and Mary's children, Maggie (fifteen) and Walter (twelve), each received two dollars per month until they turned sixteen. The nature of the relationship Charlotte had with Maggie and Walter or the larger Jay family is unclear. But there are hints she felt estranged from them or desired the closeness of her kinfolks. Formerly married to John Gibbs, whom she divorced in 1884, Charlotte, also called Lottie, did not remarry or have children of her own. For the next twenty-seven years, she worked as a domestic in private homes in Avondale, West Grove and West Chester, sometimes as a live-in servant. She died from kidney disease on September 20, 1920, at the age of eighty. She was buried in the African Union Church Hill Cemetery in Landenberg, Pennsylvania (near New Garden and Avondale), with members of her Watson family. Like some women of her era, she was laid to rest bearing both her family and married names: Charlotte Watson Jay.[34]

As he willed, William was buried at Hosanna near his relatives and ancestors and his first wife. His published obituary, probably placed by trusted friend and cousin-in-law John, revealed more of how he lived than how he died:

> *An industrious colored man, named William Jay, died yesterday at his residence near Jennersville. He was about 50 years of age and had been*

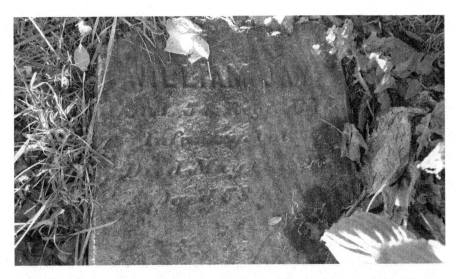

William Jay grave site at Hosanna Cemetery. William stipulated in his will that he be buried here. *Author's collection.*

ill all winter. He was a soldier of the late war. He had many friends by reason of his usefulness in doing work around the country and doing it well. Oxford Press, *May 15, 1893*

Ultimately, William died of consumption. A GAR medallion and flag decorate his weathered headstone. The unmarked graves of his son Harry; wife, Mary; and parents are somewhere nearby.

Wesley Jay

"I Was in Hot Times and Used Myself Up Entirely"

A Military Parade and Soldiers Re-union will take place at Lincoln University Station, on Saturday next, 8ᵗʰ inst. The committee announce[d] that the meeting will be addressed by Fred. Douglass, Esq., and A.H. Grimke, one of the graduates of Lincoln University. Two Brass Bands will be present; and a sham battle will be fought in the afternoon. The military organization will come from Philadelphia. Excursion tickets will be sold by the P.&B.C. R.R. from all stations between and including Kennet[t] and Port Deposit, on the above day. Oxford Press, *October 5, 1870*

Sham or mock battles such as the one staged at the Lincoln University Station in 1870 resembled twenty-first-century reenactments and were equally as popular. Begun during the Civil War, mock battles were held for a variety of reasons: they entertained civilians, provided drill practice for soldiers and most often were staged to show citizens what had happened on the battlefront.[35]

The presence of Frederick Douglass and Archibald Henry Grimke, an 1870 Lincoln graduate, indicated the political nature of this reunion of USCT veterans among Lincoln students and alumni and area residents. An early advocate for black enlistment, Douglass was forging long-term relationships with Lincoln alumni, who continued advocating for black civil rights during the Reconstruction years when both advancements and challenges coexisted. Grimke was beginning law school and would become a diplomat, newspaper editor and public lecturer, using these platforms to promote civil rights. That February, the Fifteenth Amendment to the U.S. Constitution prohibiting federal and state governments from denying blacks the right to vote was ratified. The Civil Rights Act of 1871, protecting blacks from violent attacks by white supremacy organizations, would follow, and in 1873, delegates gathered at the National Equal Rights Convention[36] to push for the eventual passage of the Civil Rights Act of 1875, guaranteeing equal treatment of blacks in public accommodations and transportation. For Wesley Jay, Hinsonville veterans and Lincoln students and alumni gathered to watch the parade and sham battle and hear these distinguished men speak, that day's ceremonies were about both remembrance and call to action. The struggle for equality continued.

Wesley T., Wesley's seven-month-old son, was too young to understand his father's pride as an activist soldier who stood up and fought for his rights while suffering injuries in battle like the one being reenacted. "I was in hot times and used myself up entirely by lifting and working while the excitement and danger was nigh,"[37] the elder Jay said later in his pension application. Newly married, the five-foot, eleven-inch veteran stood proudly among his army comrades, confident in their collective strength to continue driving social and political change in Pennsylvania and the United States. Along with his brothers and cousins, Wesley and men of the 54th advocated for equal pay while battling both the enemy and the federal government, which treated them as lesser men. Black enlisted men were paid ten dollars per month—minus three dollars for clothing. They refused their reduced pay of seven dollars, having been

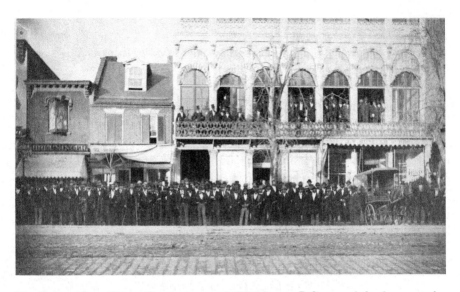

The National Equal Rights Convention met in Washington, D.C., to push for the eventual Civil Rights Act of 1875. *Library of Congress.*

promised pay equal to white soldiers. This was a point of honor for the men of the 54th, whose discipline and dedication were proven early in 1863 battles. Men of Wesley's 54th and other black regiments did not back down and continued petitioning for equal pay. An April 1864 *Christian Recorder* editorial discussed their principled determination and bravery despite government-sanctioned discrimination that also created hardships for the soldiers' families:

> *We are continually getting letters from our noble and brave colored soldiers, who have periled their lives for the sake of the Union cause, and, at the command of their leaders, have confronted the enemy, when their comrades would be shot down by their sides, and some of these men have been in the service of the Government for twelve or fifteen months, and have not received one red cent for their services. They have been offered seven dollars per month, but have refused to take that small sum. Many of these men, who have been in the service of the Government for twelve or fifteen months, have wives and children, who are wholly depending upon them for support. Now, in view of all these facts, we, in the name of God and humanity—that God who knoweth the secrets of all hearts, who beholdeth the actions of the children of men—that God to whom we have all to give an account for all our deeds—it is in His name that we call upon Congress to at once pass a*

law, that these men shall at once be paid the same as all other soldiers are paid, and that the Paymaster at once be authorized to pay the men off. We say, will not Congress do this thing?[38]

That June, one of Wesley's Company B comrades reiterated the plight of men going into battle under enemy fire while being short-changed by their government. Writing from Morris Island, South Carolina, he expressed battle-tried men's irreversible determination to invoke their country's democratic law to be paid equally:

[W]e have served our country manfully for over twelve months without receiving one cent from the Government, and all that we have for our bravery is the credit of fighting well, but we are deprived of our wages and the rights of soldiers. . . . We all cry, "Union!" and shout for the battle. It is a question whether we can call this a Union Government—a free Government—that will keep a regiment in the field fifteen or sixteen months without pay because they are black. Will you call it an honorable and just Government that gives for a reason that there has been no act passed of Congress to pay negro soldiers? If we understand the Declaration of Independence, it asserts the freedom and equality of all men. We ask nothing more. Give us equality and acknowledge us as men, and we are willing to stand by the flag of our Union and support the leaders of this great Government until every traitor shall be banished from our shore, out of the North as well as the South.[39]

Written and read in the presence of his comrades, who provided input, the soldier's words were committed to the historical record for future generations—including Wesley's son yet to be born—that black men who enlisted were treated like slaves:

When we enlisted, it was not for a large bounty nor great salary. We thought that we could help to put down the rebellion. We anticipated future benefits. We intended to distinguish ourselves as heroes and supporters of the Government, and to share alike their rights and privileges, to have the same opportunity for promotion as our bravery and ability would warrant. But our bravery is always in vain, our heroism discountenanced, our patriotism disregarded, and we are offered the paltry sum of seven dollars per month, and are given the insulting reason, that the negro is not worth as much as the white man. They cannot tell us that we do not fight as well nor die as freely as the white man, but they can tell us they are a majority, and,

therefore, assume presumption of their power, and intend to compel us to involuntary servitude, or, in other words, compel us to work for half pay, which is involuntary servitude.[40]

Appealing to the moral authority on which America was founded, these soldiers urged President Abraham Lincoln, issuer of the Emancipation Proclamation who decisively denied them equal pay, and Congress to "consult the God of nations and reconsider His instructions with the dictates of their consciences, and every soldier will receive equal compensation according to his merits." The writer, who signed his letter "E.W.D. Co. B, 54th Mass. Vols.," restated his comrades' patriotism in closing: "Give us our rights—acknowledge us as men and citizens—and we are willing to flood rebellious cities with pools of our blood, and never lay down our arms until every vestige of rebellion is driven from our land."[41]

As readers absorbed the sentiments captured in these *Christian Recorder* editorials and letters, Congress enacted a bill on June 16, 1864, authorizing equal and full pay to black enlisted soldiers, who had been free as of April 19, 1861. Finally, on March 3, 1865, Congress passed the Enrollment Act and granted retroactively equal pay to all black soldiers.

Wesley returned home that September too ill to walk. A wagon hauled him from Elkview Station to his father's house, where for five months he was mostly confined to bed with "fever and some chills" and pains due to a hand wound and what was soon diagnosed as a ruptured hernia. Eventually, he recovered and tried to re-enlist, along with his cousin William Walls, a younger brother of the deceased Albert Walls. William vividly recalled their experience and Wesley's failing health:

About September 1866 we went to Wilmington, DE to enlist in U.S. Regular Army by Sergeant Maloney. I was in the room with Jay when he was examined by Medical Board, stripped naked going through motions. The surgeon said claimant had hernia rupture, was not fit for service, had better go home. He told me I was consumptive and would not stand it. He rejected us both. Claimant has been disabled from heavy work ever since.

William Walls
Aged 39 years[42]

Rejected for further military service, Wesley found work as a cart driver and hostler. His initial pension claim in 1879 cited recurring malarial fevers

and pain caused by his hand wound and ruptured hernia. He believed the rupture occurred during his Pioneer Corps detail "carrying heavy timber for breast works at Jacksonville, Florida, about September 15th 1863" and the "gunshot wound through left hand" at the Battle of Fort Wagner, Morris Island, Charleston, on July 18, 1863, while under the command of the heroic Colonel Robert Gould Shaw, whose name he strategically mentioned in his application. Family doctor James Fulton verified the hernia rupture in Wesley's lower intestines, left index finger damaged due to gunshot and recurring chills and fever as having "fully originated from service in the line of duty"—all of which were likely to continue to plague Wesley the rest of his life and entitled him to two dollars per month.[43]

While Wesley's 1881 testimony stated he incurred the hand wound at Fort Wagner on July 18, 1863, and regiment records and history indicate he was wounded on April 18, 1865, at the Battle of Boykin's Mill, South Carolina, some of his subsequent disability claims were approved.[44] Between 1879, when he first filed for a pension, and 1903, when he died, the highest monthly benefit he received was six dollars. Five days after Wesley's death, Jane Jay filed a widow's pension claim. She began receiving benefits seven months later—but only after neighbors attested to the Jays' marriage and Wesley's death.[45] It is likely Wesley and Jane were married at Hosanna, which had several itinerant or short-term ministers.

Twenty-three years later, Jane—then living with her daughter's family in Coatesville—requested an increase:

> *I was the wife of the person on account of whose service during the Civil War I am drawing pension during the period of his service in said war, and therefore I request consideration of my case with a view to the allowance of the $50 rate provided by the act of July 3, 1926.*
> *Jane Jay*
> *Coatesville, Pa*
> *RFD No. 6*[46]

The act of July 3, 1926, allotted a fifty-dollar monthly pension to a war widow, provided she was married to the soldier during his period of active service. Commissioner of Pensions Winfield Scott informed the eighty-one-year-old Jane of this in a form letter; Wesley and Jane were married on October 3, 1865, more than two months after his discharge.[47] The elderly widow subsisted without an increased pension for another twenty-two years until her death: "Mrs. Jane Golden Jay, widow of Wesley Jay,

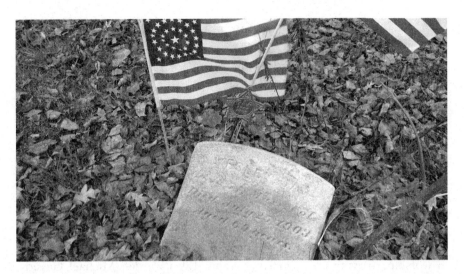

Wesley Jay grave site at Hosanna Cemetery. *Author's collection.*

Sr., Civil War veteran of Oxford died at the home of her daughter, Mrs. Harvey Rider of Newlinville."[48]

The longest living Hinsonville USCT veteran widow, Jane "Jeanie" Golden Jay, died on September 2, 1948, at the age of 103. She was buried in Hosanna Cemetery along with her husband, some of her children and members of the extended Jay family.[49]

Wesley T. Jay, who grew up hearing about his father's bravery and preceded his mother in death by eight years, was also buried at Hosanna. Like his father, he appeared to have been well regarded in his nearby Coatesville community:

> *Wesley T. Jay, a well-known resident of Coatesville, died on Friday in West Bradford township. Mr. Jay was born in Oxford on March 6, 1870, and was a son of the late Wesley and Jane Golden Jay. He came to Coatesville from Baltimore, MD, and for forty years worked in the steel mill. For many years the deceased was a Squire in South Coatesville, and finally had to give up his position on account of poor health. He will be sadly missed by the many relatives and friends by whom he was highly respected.[50]*

Though his funeral was held in Coatesville's Bethel AME Church, Wesley rests in ancestral burial ground with some of his siblings and parents. The elder Wesley's decorated headstone shows his and the family's pride in his 54th Massachusetts service.

GEORGE JAY

"We All Feel a Want When the Clock Does Not Strike"

October 25, 1882, Eastern State Penitentiary, Philadelphia—The clock was not working, a void noticeable to both inmates and guards. The clock sanctioned, by function, the occasional reprieve to the silence mandated for inmates entombed in their solitary cells. Guards working protracted shifts longed for its hourly promising bells, too. For the inmates—confined to cells they were rarely allowed to leave and that muted most sounds—regular bells tracked the coming and passing of time. For the man or woman clinging to sanity in silence, the bells were reminders of life outside. Bells, whistles and rings announced the beginning and ending of workdays, school days, calls to worship, arriving and departing trains. Even warden Michael Cassidy yearned to hear the clock again. "Our clock which rings the hour is broken in some part and does not strike, which is a great inconvenience to the prisoners who are accustomed to hear it strike every hour," he confided in his journal. "We all feel a want when the clock does not strike."[51]

On this October day, George Jay had served more than five years of a twelve-year sentence for larceny. One of 964 inmates, he lived alone in a cell illuminated by a small orb of light glaring through a permanently sealed, unreachable ceiling window. *God's Eye.* Prohibited from speaking even to himself at any time, he ate and worked alone under the watchful eye. Classified as a "jobber," one who lacked a skilled trade, the former combat soldier, who survived one of the war's bloodiest battles, was given odd, menial jobs. He exercised alone for thirty minutes or an hour each day within a walled-in yard attached to his cell that prevented him from talking to inmates on either side or they to him. A moral instructor sometimes visited, offering Bible tracts that meant little, as George could not read. Every Sunday, he and the other 963 inmates listened to religious services held at the end of the corridors from their cells under God's watchful eye.

George arrived at Eastern on May 9, 1877, four days after he was convicted of four counts of larceny in Chester County Court and sentenced to twelve years. Sam Caldwell, transported with him from the same county jail on the same day, was convicted of two counts of larceny, which he and George committed together. Known also as "Happy Sam," Caldwell received a shorter sentence, six years. Yet soon after they passed through Eastern's medieval fortress walls, their different sentences and identities become mostly indistinguishable: George Jay, the five-foot, eleven-inch, illiterate, married

thirty-year-old black laborer, with black eyes and hair, became no. 8829. Sam, alias Happy Sam Caldwell, the five-foot, nine-inch, literate, married twenty-five-year-old black laborer, with black eyes and hair, became 8830.[52]

This was the last time they would see or speak to each other. After processing, their heads were covered with cloth masks, and they were led to solitary cells. George was placed in Cell Block 2, where he would stay until his release on January 5, 1888. He served ten years and eight months of his twelve-year term, which was shortened due to commutation law intended to reduce overcrowding. At the age of forty-one, he re-entered a world of sounds in which humans freely converse with one another, but as a mentally disabled man unable to care for himself, George was too burdensome for his family to handle.

Happy Sam Caldwell mysteriously died in his cell on May 4, 1879, two years and one day after being sentenced. No cause of death was listed—just an entry that it occurred. Nor is there a record of his burial. Although listed as married and literate, no record of Sam's life before his conviction or after his death has been found. If no relatives or friends claimed his body, it might have been used for science. Under such circumstances, state law allowed the Pennsylvania Anatomical Society to take unclaimed bodies. Such were the fates of inmates "A3232 James Lucas Negro" and "A2952 Negro," whose bodies went to the society. Designed mainly to curtail grave robbing, much of which occurred in Philadelphia's black cemeteries, the Anatomy Act of 1883 permitted statewide distribution of unclaimed bodies, and individuals who did not request burials, for dissection. Unclaimed bodies of Eastern State inmates were provided for such medical experiments.[53]

George's life was not always so bleak. He was raised in and belonged to a close-knit, nurturing family and protective community. In March 1863, he enlisted with his brothers and cousins and served without incurring any serious injuries—or so it seems. George was discharged in 1865 without any stated illness or injury, but after he returned home, relatives and neighbors began noticing things about his behavior. Something was not quite right. The army experience did something to his head, they murmured. George tried readjusting to life as a civilian, working as a day laborer. He liked to drink sometimes. He settled into a relationship with Mary Armstrong, who on March 1, 1872, gave birth to their son Joshua, whom they named after his grandfather. But unlike his brothers, cousins and neighbors who served as USCTs and resumed stable lives after the war, George veered down a different path that led to the penitentiary and, later, the insane asylum.

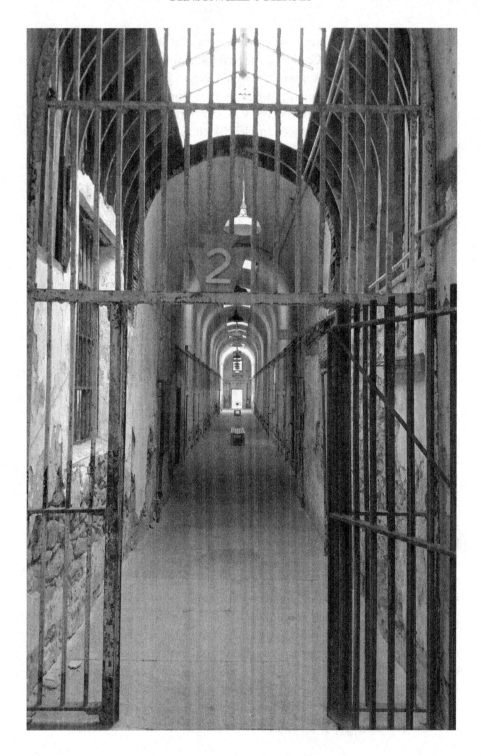

Left: Eastern State Penitentiary restored solitary cell. George Jay lived in a cell like this one for nearly eleven years. *Author's collection.*

Below: Eastern State Penitentiary, Philadelphia. Originally a prison that imposed solitary confinement and silence, today it is a museum that addresses criminal justice reform. *Author's collection.*

Opposite: George Jay's cell was in block 2. Inmates rarely left their cells except for brief exercise in confined spaces to prevent communication. *Author's collection.*

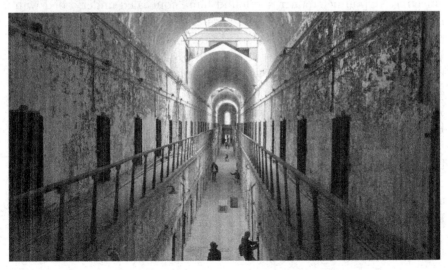

Joshua was five years old when his father was arrested, tried, convicted and sent to prison.

George, Sam and six members of their crime ring were convicted of a series of larcenies that occurred between January and April 1877. According to trial testimonies, their acts were part of a larger fencing operation that encompassed neighboring counties and several townships and probably operated longer than the period of crimes traced to them.[54] By late April, George, Sam and at least six other males and females had been accused of burglary, larceny and receiving stolen goods in areas of southeastern Chester County and neighboring Lancaster County, including Lower Oxford, Upper Oxford, West Grove, Coatesville and Lancaster. Codefendants who were implicated and/or incurred lesser sentences for receiving stolen goods include John Hopkins, Jonas Nash, Amico Nash, Charles Jones, Amanda Jones and Katie White. George, the mastermind, and his right-hand man Sam seemed to savor the adventure of their enterprise and were implicated in most of the cases. Whether George and Sam had steady jobs was unclear; however, they supplemented their income with stolen money, food, clothing and an occasional gun.

A series of burglaries occurred, and they were the prime suspects. Coatesville grocer E.D. Baldwin claimed that in late January, George and Sam broke into his store and stole eight dollars. As the theft was "committed in the night time," the grocer had "just cause to suspect" them. So did Abbie Maule, a housewife living in Highland Township (east of Cochranville), who accused George of entering her house in February while she attended "meeting." Upon her return, she found him "concealed under a bed with intent to commit a felony." She said both George and Sam stole "one pair of gloves of the value of one dollar, and two dollars of money altogether." Upper Oxford farmer Charles Colgan accused George of "entering his house on or about the first of February…and taking and carrying away one coat, one turkey, some butter, a lot of meat, and about $30.00 in money."[55] W.W. Kinzer, a farmer living in New Holland, between Coatesville and Lancaster in Lancaster County, claimed that sometime in March his house "was entered by burglars" and that "a lot of valuable goods" were stolen and he "has just cause to suspect Happy Sam." An early April warrant based on Kinzer's complaint also charged George and two others with burglary and receiving the stolen goods. Six witnesses were summoned to support Kinzer's claim.[56]

William Gawthorpe operated dry goods and grocery stores in New London and London Grove and accused George, Sam and an accomplice

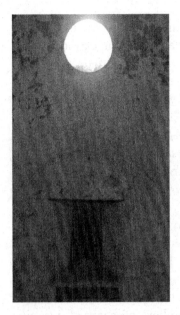

God's Eye, a small ceiling or wall skylight that illuminated each cell. Under this watchful eye, an inmate reflected on his/her crime. *Author's collection.*

of stealing fifty-one dollars' worth of goods, including cassimere fabric, blankets, six pairs of shoes and "money from [his] drawer," in April. Nearby resident William Eachus said George, Sam and an accomplice stole "one pistol of the value of five dollars [and] one overcoat of the value of fifteen dollars." Lower Oxford housewife Annie McIntyre accused George, Sam and four others of stealing "one cloth coat" valued at fifteen dollars.[57] George pleaded not guilty to all charges but was convicted.

"This being Christmas, our prisoners were provided with an ample dinner of roast beef, mashed potatoes and turnips and apples. December 25, 1877." The warden's cheerful December entry implied a calm, controlled environment at Eastern. Yet six days later, an inmate climbed into an empty molasses barrel that transported him out of prison and to freedom. Officers sent to hunt for him were unsuccessful. Though rare for the period, the escape was one of diverse tactics inmates used to escape the model prison's mandated silence that drove some of them, if not most, insane.

This was George Jay's first Christmas dinner as an Eastern inmate.

Built in 1829, Eastern was designed to reform the inmates' minds. It was believed that keeping prisoners isolated and silent in chapel-like cells with the God's Eye peering in and through their souls induced them to repent for crimes committed against fellow citizens and society. Despite its reputation for benevolent reform, Eastern was criticized throughout its history for the use of solitary confinement, which many believed caused insanity. Three times within its first seventy years of operation, in 1834, 1897 and 1903, Eastern's management practices and the physical and mental condition of inmates were investigated. Charges prompting the 1897 investigation alleged that "cells of the prison were in a filthy condition, that the diet was of inferior grade, and that there existed an attitude of indifference if not cruelty toward some of the inmates, especially those who were insane."[58]

Perhaps as an effort to offset the trauma that silent isolation induced, prison officials occasionally allowed inmates' relatives to visit. Cassidy's 1882 journal entry here describes how railroad companies supported the effort:

> *Many people were here to visit their friends and relatives who are here from the different counties. The railroads are carrying them for reduced fare during this celebration, and many poor people who have relatives in this prison are taking advantage of the opportunity offered them to visit them. When they come from the county or a distance they are permitted to see their friends by the warden without an inspector's pass or order.*[59]

George's mother, Lydia, visited him when possible. Seeing her son's deteriorating mental state, she tried to reassure him. Neither she nor his family would abandon him. His sister Rachel and her husband, Daniel Jones, adopted Joshua, who attended school in Lancaster where they all shared a home with Lydia, who worked as a housekeeper. Meanwhile, Cassidy recorded increasing numbers of cases of insanity among inmates, a health issue the prison was ill-equipped to handle and prompted some inmates' families to request relocations to insane asylums. Wavering between contempt for the problematic inmates and frustration with the court weighing down Eastern with mentally ill people who should be housed elsewhere, Cassidy's entries provide examples of how solitary confinement affects the mind as well as how inmates cope with it:

> *A204 Arthur Ritchey sentenced...to 11 years and 6 months...committed suicide last night by hanging himself with a sheet to the back door of the cell he occupied....He has been a lunatic since he came here. Has not been able to walk or help himself for two years.*[60]

> *A1865 who is insane from masturbation and has to be taken out in the yard and specially cared for. He struck his attendant with a shovel when his back was turned. This prisoner is giving us a great deal of anxiety to prevent his injuring himself or someone else.*[61]

> *There is now about sixty insane or looney prisoners here at this time. Population: 1048.*[62]

A126 was taken to the Insane Hospital at Norristown by officer of court. There is more cranks in the house now than was ever known to be at any time in the past. Some of them are very dangerous and malicious.[63]

Typical of the time, Cassidy and Eastern officers regarded masturbation as a form of mental illness or low character and copiously documented cases they observed. Inmate A2879 was one of many engaging in this behavior:

A2879 who is a confirmed masturbator and is likely to be troublesome. That class of prisoners are becoming more numerous. The court sends all the weak people here and we have to take care of them and do the best we can with them.[64]

Appearing in the warden's logs as frequently troublesome, inmate A1868 typified inmates who suffered both mental disabilities and untreated, debilitating health issues. Erratic and often refusing to do assigned jobs, Cassidy said, "A1868 who is a lunatic and is being treated as such" must be continuously supervised, as "he has made several attempts to injure himself and others making repeated attacks on those having charge of him."[65] Sadly, this inmate deemed "very insane" soon died, and an autopsy revealed a "decayed" brain and diseased lung. "His body was disposed of by law to the anatomical society of the state."[66]

Confined to dimly lit cells, inmates longed for sunlight, and many asked to be allowed to work and exercise outdoors more often. "They say their health requires it, that the [prison] doctor tells them that it is what they need," noted Cassidy, who granted most of their requests.[67] But the career warden was not readily manipulated by requests that seemed less than credible. He suspected one inmate of feigning insanity to get more sunlight:

A1749 who appeared to be losing his mind and was put to work in the wash house some three weeks ago recovered his usual health and condition of mind. But on being left in his cell today he showed signs of returning lunacy which fact convinces one that insanity was simulated for the purpose of getting out in the yard during the day.[68]

An inmate caught trying to communicate faced loss of privileges or an extension of sentence:

> *A1397 tenth block lost the privilege of an hour exercise in outer yard by misconduct communicating and getting other prisoners to do messages for him. He is an English thief of the crime class.*[69]

> *A1989 Caleb Bennet Negro was discharged by the commutation law but not until late in the afternoon in consequence of violation of rules of communicating with other prisoners during the night. He was a frightened Negro, thought he would be kept the full term of his sentence.*[70]

The warden's entry describing the effects of long-term isolation on inmates foreshadowed George's mental state:

> *A1923 Negro in sixth gallery was shouting and hallowing all of last night. He is very looney. His time expires by commutation on the fourth of this month, that is the day after tomorrow. He is not in condition to discharge.*[71]

The December 25, 1887 entry portrayed another sedate Christmas at the prison:

> *Christmas day, clear and pleasant. Sunday the usual religious service by volunteer directed by the moral instructors assisted by Dr. Davis. There were a very fair attendance of preachers and singers, all the blocks being supplied at the same time. As Christmas falls on Sunday the day is celebrated on tomorrow Monday. Therefore, the Christmas dinner will be served then. Sauerkraut for dinner today the first for the season. It was very good.*

This was George's last Christmas dinner at Eastern. On January 5, 1888, his sentence expired. Though eligible for release, he could not leave yet because of his condition:

> *A8829 George Jay negro whose time expires today by commutation was not discharged for the reason of his mental condition being such as to render him incapable of taking care of himself, he has served ten years and eight months convicted in Chester County of larceny on four charges on which he was sentenced to three years each. His mother is living and promised to come for him when the time would be up. If she does not come, he will be sent to an insane hospital.*

Lydia was then living in Reading, Pennsylvania, and may not have been able to come for George right away. Almost four weeks after his scheduled discharge from Eastern, on February 3, 1888, the Chester County Hospital for the Insane admitted him. He was described as a forty-two-year-old black male of Chester County, unable to read, able to write his name, not able-bodied, insane and "just out of penitentiary." He was discharged on April 28 after staying less than two months.[72]

Relatives took George home to Hinsonville and tried to take care of him. But nine months later, on December 20, he was readmitted to the county hospital. Discharged on January 19, 1889, after staying less than one month, he was readmitted about two weeks later and then sent to the Norristown Hospital for the Insane on February 15. Slightly over a year after being discharged from Eastern, George began a second phase of institutional confinement that would last for the rest of his life.[73]

Four years after George was committed to Norristown, Joshua, now twenty years old and living in Lancaster, married Lillian Morton. Joshua's mother, now using the name Mary Waters, provided her consent, as required.[74] Joshua held a steady job as a hotel waiter and could read and write. He and Lillian remain married for nineteen years.

In 1895, an appointed "Guardian Committee" led by asylum steward C. Brinton Swisher, in conjunction with Oxford attorney Theodore Stubbs, who handled most of the Hinsonville men's pension claims, filed an application purportedly on George's behalf. The claim stated that "he is insane, confined and unable to earn a support by manual labor by reason of being insane and is a lunatic in the Norristown Pa. Insane Asylum" and was reportedly "wounded in army and discharged sick."[75] Lydia had disappeared from public records by this time, and no Jay relatives' names appeared on the pension claim. George's brother Wesley, who used attorney Stubbs's services, may have been aware of the claim filed for George. However, asylum officials appeared motivated to secure funds through the Dependent Pension Act of 1890. Passed with considerable lobbying by the GAR, the act provided pensions for veterans incapacitated by disability and unable to perform manual labor, even if the disability was not a direct result of the war. All disabled Union veterans who served ninety days and had been honorably discharged were eligible. Thus, George, an institutionalized, mentally disabled person, qualified for a pension. Neighbor and friend Emery Wilson signed a supporting statement:

I was well acquainted with George Jay both before the war of 1861 and since his discharge from the army until he was sent away to the Asylum and to the best of my knowledge and belief soldier's insanity is not due to vicious habits. Emery Wilson[76]

Though the alleged combat wounds were never documented or the claim approved, the application provided some details about George's characteristics, health and living conditions. The examining surgeon described him as forty-eight years old, standing five feet, eleven and three-quarters inches, weighing 168 pounds and having irreversible dementia:

We find a tall ungainly fairly nourished Negro, with silly expression of face, shuffling walk, answering questions at times in a meaningless way, complaining of no particular ailment. Man has been in Asylum eight years is afflicted with terminal dementia with no hope of improvement. He attends chapel and performs a small amount of light labor for the institution under guidance, is addicted to self-abuse, is unable to care for himself.[77]

The 1900 census listed a George Jay, fifty-one, single, as a patient of the State Hospital for the Insane Norristown Borough who could read, write and sign his name. The 1910 census noted seventy-year-old George as an inmate of the Chester County Insane Hospital in West Bradford, about fifteen miles from Hinsonville, where he had been transferred. George turned seventy-one before dying on July 9, 1911. The physician who had been treating him for a week pronounced him dead at 3:00 p.m. on a Sunday, perhaps after he attended chapel service. Presumed cause, heart attack.

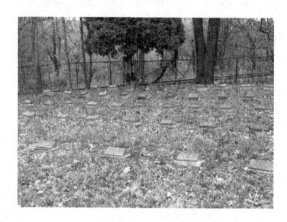

Former Chester County Asylum for the Insane Cemetery. *Author's collection.*

George Jay was buried in an unidentifiable grave in the County Home Cemetery–Embreeville in what was essentially a potter's field; the plot still exists today. It contains more than two hundred charcoal-gray numbered stone tablets whose corresponding index identifying the deceased was lost.[78] George's son Joshua died later the same year in October from "nervous affection," according to a newspaper obituary: "Joshua T. Jay, a former resident of Oxford, died Friday in the hospital in Lancaster from a nervous affection. He was 33 years old, is survived by a wife and one daughter. Mr. Jay had been living in Lancaster for several years."[79]

JAMES COLE AND JOSIAH COLE

Brothers by Birth

James and Josiah resembled each other in height, complexion and lifestyle. At first glance, the 54th Massachusetts descriptive book entries for the brothers by birth appear to be duplicates.

James and Josiah married the same year, remarried and were widowed, although at different stages of their lives.

James worked in Coatesville after the war, living there for a while with his cousin George Jay, who ran afoul of the law. In 1876, he married Katie Lapin, who had a daughter, Catherine, from another relationship, and they settled in the East Marlborough area, where he worked farming jobs while she kept house. But Katie had another plan for her life. James divulged in his 1898 pension increase application that she "ran away" and moved to Kansas. But he, too, moved on. He fathered a daughter, Bertha, in 1890 with his housekeeper Annie, whom he married.[80]

James qualified for an immediate two-dollar monthly pension upon discharge due to a battle injury on July 18, 1863, when he "was wounded in the rite [*sic*] knee very near the joint at the storming at Fort Wagner, South Carolina," during the "time Colonel [Robert Gould] Shaw was killed." He was hospitalized for two months following the high-casualty battle, which he, Josiah and their three Jay cousins miraculously survived.[81]

Between 1865 and 1907 (the year of his death), he was receiving eight dollars monthly. However, James's health steadily declined, and he could barely work. In 1882, John Shirley of West Chester, who served with him in the 54th, attested to James's petition for an increase, describing how his

Descriptive book, 54th Massachusetts Infantry Regiment. James and Josiah Cole appear as nineteen years old, although they were born more than one year apart. *Fold3.com.*

The Storming of Fort Wagner, Morris Island, South Carolina. James Cole was wounded on July 18, 1863, during this high-casualty battle. *Library of Congress.*

friend lived with debilitating pain: "Gunshot wound of right knee, wound at all times painful and troublesome. At times, he is entirely disabled for work. The disability increases."[82]

In 1892, when he requested an increase, James was living in Kennett Square and suffering from multiple handicaps and illnesses. The examining physician noted, "During the last 10 years he has been troubled with piles, accompanied with pain, bloody stools and constant discharge."[83]

James's increase request six years later revealed his continuing health problems and somewhat complicated love life. Explaining his and Katie's relationship, he said they were married in Somerset, Pennsylvania, in 1876 by Reverend William Johnson. The 1880 census listed James, Katie and

stepdaughter Catherine Samons living in East Marlborough. The 1890 veterans' census placed him in New Garden; Bertha was born on May 10 that year. In 1900, James, Annie and Bertha were living as a family in East Marlborough. Thus, between 1880 and 1890, Katie ran away and James took up with Annie.[84]

Cause of Death: Run Over by a Trolley Car[85]

James was hospitalized and treated at West Chester Hospital for more than four months before succumbing to his injuries. He died on March 30, 1907, a sixty-five-year-old widowed laborer. How and when Annie predeceased him is unclear. He was buried in Union Hill Cemetery in Kennett Square.

United in Marriage

Josiah Cole and Harriet Moore of Coatesville were married on April 13, 1876. Josiah had been previously married to Ella Brown, who died in 1872.[86]

Josiah applied for a pension in 1886, and he received six dollars per month. That amount had increased to sixteen dollars by 1889 and continued until his death in 1902. He was pensioned for brain fever and piles and later claimed for rheumatism and near total deafness of his right ear.

His 54th Company B comrades John Shirley's and Enos Spriggs's summarized, supporting statements vividly describe Josiah's wartime suffering and its effects on his health:

> *Beginning of the year 1864 at or near Fort Green, SC, the said Josiah Cole fell from the ranks and was carried to the hospital tent. He never was engaged in active duty afterwards. Brain fever was followed by rheumatism and deafness of the right ear. He was discharged with his regiment August 20th 1865. Have seen him frequently every year since his return from the army. He has suffered with rheumatism and deafness ever since.*[87]
>
> *I remember him having a brain fever on Morris Island, S.C. Was out of his mind. It was the latter part of 1863. I cannot remember the month. And in summer of 1864 I think in August he had a sun stroke while on duty. Lost the hearing of right ear which he has never recovered. About the middle of April 1865 he contracted rheumatism*

from force march and exposure and rain in South Carolina on a raid from
Georgetown to Camden, SC.
Yours John F Shirley[88]

In February or March of 1865 at Black River Dam, SC, Josiah contracted
rheumatism due to extreme exposure, and about the same time suffered
chronic diarrhea and piles. He had a sun stroke the summer before which
affected his head and left him hard of hearing. I saw his piles frequently.
He suffered very much from them and was also very much crippled up with
rheumatism. I know these facts by serving in same company with him. Enos
X Spriggs[89]

Josiah provided an exhaustive statement on July 30, 1889, describing
the treatments he sought for his varied ailments. Certified by the Chester
County court clerk, the statement was deemed valid documentation and
enabled him to receive an increase:

Shortly after I came home from the army in the Fall of '65, I was treated
by Dr. Gomes for piles and rheumatism, who at the time resided [at] Corner
of 6th and Lombard streets, Philadelphia, PA. I was an office patient, going
there frequently for treatment and medicine. He told me that while he could
relieve me that my case was incurable, he treated me for both the piles and
rheumatism, and afforded me relief from both these troubles. My disability
being pronounced incurable by the Doctor and other remedies that cost me
less money and seemed to answer my purpose just as well and for this reason
he never had any medical treatment affidavit of treatment from the fact that
he is now deceased, having died some ten years ago. In relation to further
testimony of neighbors, I can obtain further testimony covering the last few
years, but of those who knew me intimately about the time of my return
from the war, several are dead and some are scattered so that I have lost all
trace of them, among the latter I might mention the parties who employed
me as hostler while I was in Coatesville, these parties could tell all about
my disability, but they have gone out west and although I have tried I have
failed to obtain any trace of them. In relation to the piles it is a disability
of a character that one would hardly show to everybody.
Josiah Cole

Between 1890 and 1902, Josiah, Harriet and their five children lived in
East Downingtown and East Bradford, where Josiah owned a farm and

where he died at the age of sixty-two—five years before his brother and one year after his mother, Rachel, who was buried at Hosanna. Having maintained affiliation with the AME denomination, Josiah was laid to rest in the northeast section of the Bethel AME Cemetery in Downingtown.[90]

Harriet's widow pension began that November: twelve dollars per month plus two dollars for each of her four children, the unnamed fifth child having died. By 1917, her pension had increased to twenty-five dollars, but on May 18, 1926, she wrote in a labored hand to the Pension Office, inquiring about an increase:

> *dear Sir i rite to the department of interior Bureau of pensions for to know a bout the increce of my pension i would like to have a little more if posable i am unabel to work out and would like to have a little more i am living alone have rent and tax to pay living is high and my helth is in bad condishen and i would be very thankful to receve the same Harriet i Cole*
>
> *i am the widow of Josiah Cole and did all i could when called on for the wars and veterans and believe in legislation*
> *yours very truly*

The commissioner's June 10, 1926 terse form letter informed the seventy-one-year-old widow then living in West Chester that she was receiving the highest pension rate allowed:

> *Madam:*
> *In response to your communication relative to increase of pension, I have to advise you that the $30 per month which you are now receiving under the act of May 1, 1920, is the highest rate to which you are entitled under any existing law.*
> *Respectfully, Winfield Scott, Commissioner*

"In Case I Should Be Shot Please Send This to My Home, Elkview"

ROBERT G. FITZGERALD

Readville, Massachusetts, January 5, 1864—Robert George Fitzgerald began keeping a diary soon after he enlisted as a private in the 5th Massachusetts, a cavalry unit that remained unmounted through most of its service. He worked as a seaman for six months before making his way to Readville. Before then, he worked for the Civil War Quartermasters Corps, which hired able-bodied men, black and white, as teamsters, wagon drivers and laborers. Robert; his brothers Richard and William "Billy," who later enlisted in the 41st; and cousin Tillman Valentine, the 3rd Regiment poet, were hired in 1861 and earned up to thirty-five dollars per month—a decent income between farming seasons.

Already beginning to lose his eyesight from an injury while at sea, Robert soon experienced the front firsthand, where he could be wounded, even killed. If he did not survive, this Hinsonville patriot wanted his diary to be sent "to my home, Elkview. Chester Co. Pennsylvania."[91] Like cousin Tillman's prophetic poem of breaking "slavery's brutal chain," Robert's diary described black soldiers bringing pro-slavery Rebels to heel while proving their gallantry and determination to be equal citizens within a reformed, united America, stories formal historical accounts often overlook.

From 1864 to 1871, Robert was journaling about his Union army tour; his studies at Ashmun Institute/Lincoln University before and after the war; forming freedmen schools in Virginia and North Carolina; and, finally, homesteading in North Carolina, where he established a brickmaking business. His diary chronicled a Chester County man's connection to and

Elkview Station, a part of the Philadelphia and Baltimore Central Railroad. Robert Fitzgerald enjoyed walking here alone and with friends. *Chester County Historical Society.*

involvement in documented regional and national nineteenth-century history. In 2017, Robert's former Durham, North Carolina home, now the Pauli Murray House, which honors his granddaughter, a renowned civil rights activist, lawyer, writer and the first black woman ordained an Episcopal priest, became a National Historic Landmark. Raised there for part of her childhood, Pauli credited this house as the place where her human rights values were instilled, once calling it "a monument to my grandfather's courage and tenacity."[92] Robert G. Fitzgerald, an Ashmun/ Lincoln University dropout turned soldier, teacher and businessman, wrote himself into America's historical narrative.

Driven to defend his country as a soldier and to teach at freedmen schools in the South despite threats by the Ku Klux Klan, Robert came from a family that defied societal constraints and was not easily intimidated. His once-enslaved mulatto father, Thomas, married Sarah Ann Burton, a white woman with whom he bought, sold and owned land in three states: Delaware, Pennsylvania and North Carolina. Thomas was manumitted in Wilmington,

Robert Fitzgerald's granddaughter Pauli Murray transcribed his Civil War diary and researched the family's involvement in the Underground Railroad. *Schlesinger Library, Radcliffe Institute, Harvard University.*

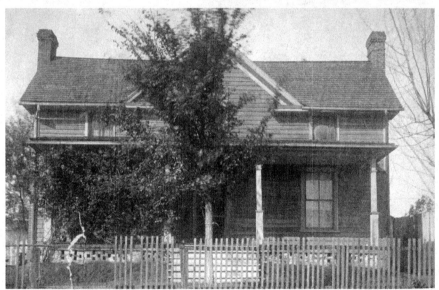

Robert Fitzgerald's former house in Durham, North Carolina, now the Pauli Murray House, designated a National Historical Landmark in 2017. *Schlesinger Library, Radcliffe Institute, Harvard University.*

Robert Fitzgerald as an older man dons his veteran uniform. Robert had lost his eyesight by the time this photo was taken. *Schlesinger Library, Radcliffe Institute, Harvard University.*

Delaware, on August 8, 1832, by Quaker George Lodge, who had inherited slaves from his father, Samuel. Twenty-four years old when freed, Thomas kept his past hidden from his children, who believed he was the son of an Irish gentleman. Great-granddaughter Pauli would uncover his slave origin decades after his death.

The Delaware Fitzgeralds first bought land in Upper Oxford in 1855 and settled their biracial family near Ashmun, where Robert enrolled from 1859 to 1861 before joining the quartermasters. The couple owned two other farms in the Upper Oxford–Nottingham–Oxford area. The Hinsonville homestead consisted of thirty-two acres for which they paid $1,632 in cash and owned free and clear. According to the 1860 census, Thomas's real estate was worth $1,200, his personal property $400.

The Fitzgeralds attended Hosanna, where they mingled with people associated with a complex network of Underground Railroad operatives fervently devoted to personal liberty and willing to defend it with weapons. Oral history holds that some Hinsonville residents joined the armed 1851 resistance led by William Parker in nearby Christiana, Lancaster County, against slaveholders who tried seizing fugitives who had sought refuge there and who had probably passed through Hinsonville with the aid of residents.[93] In the 1950s, Pauli interviewed Hinsonville descendants who said Hosanna was a transfer point for fugitives going west to Christiana:

> *Weekends provided the best opportunity for escape since slaves were off duty from Saturday noon until Monday morning. If they were successful in reaching Hosanna Meeting House while the meetings were in progress they mingled with the congregation and would drive away in a wagonload of free Negroes who hustled them to the next Underground station.*[94]

Pauli's great-grandfather Thomas was one of many unnamed black abolitionists who quietly assisted fugitives passing through en route to other safe houses operated by more widely documented Quaker abolitionists like Charles Hambleton, who lived within walking distance:

> *There were three well-traveled Underground Railroad routes fanned out within a few miles of his farm and one went right past his place about a mile to a lane which led into Hambleton's farm, an active Underground station. Hambleton's place was so close to the Fitzgeralds [one] could see the double chimneys of the big two-and-a-half-story stone house rising out of the hollow beyond two ridges to the northeast. On the way to it, little*

Hosanna Meeting House on the right and Great-Grandfather Thomas'
barn on the left were easily recognizable landmarks. When a shabby
stranger slipped out of the woods at the end of his field one evening around
dusk and asked Great-Grandfather Thomas if he could sleep in his barn,
he thought little of it. He sent him up to the loft and told him to stop by the
house next morning for breakfast, but the stranger was gone before dawn
and Great-Grandfather Thomas thought one of his cows gave a quart less
milk than usual. Before long strangers came along pretty often asking to
sleep in the barn. Great-Grandfather Thomas never turned anyone away;
he merely relieved him of his pipe or smoking tobacco or matches if he
had any before sending him up to the loft. "Don't tell me anything about
yourself," he'd say. "Just mind yourself and don't set my barn afire."[95]

The Fitzgerald log cabin no longer exists, although the white brick house
said to be Hambleton's former house can be seen one mile east of Hosanna
on U.S. Route 1 near Penns Grove Meeting. Although people of free status,
the Fitzgeralds bolted their door and slept with loaded rifles within reach to
protect themselves from posses chasing fugitives or gangs out to kidnap free
blacks to sell into slavery.

"PROVE OUR LOVE OF LIBERTY AND THAT WE BE MEN"

July 4, 1863, is said to be the turning point in the Civil War, with two battles
resulting in Confederate defeats: the Battle of Gettysburg in Pennsylvania,
fought from July 1 to July 3, and the fall of Confederate Vicksburg,
Mississippi, on July 4. Two days later, tireless advocate for black enlistment
Frederick Douglass was on his feet, holding forth in Philadelphia:

Young men of Philadelphia, you are without excuse. The hour has arrived,
and your place is in the Union army. Remember that the musket, the United
States musket with its bayonet of steel, is better than all mere parchment
guarantees liberty. In your hands that musket means liberty; and should
your constitutional right at the close of the war be denied, which, in the
nature of things, it cannot be, your brethren are safe while you have a
Constitution which proclaims your right to keep and bear arms.[96]

Thereafter, he made his way into Delaware, Chester and Lancaster Counties, spurring black men like Robert into action:

MEN OF COLOR. Frederick Douglas [sic] spoke to the colored men of Delaware county, on Monday evening last, at Chester; to those of Chester county, on Tuesday evening, and to those of Lancaster on, Wednesday evening. He urged them in eloquent terms to enlist for the war. Village Record, *July 21, 1863*

Within two weeks after Douglass's Philadelphia speech, Robert signed up as a seaman in New York City, and he served until deciding to make his way the next year to Readville, where the 5th Cavalry was being formed at the same training site as the 54th, which six of his Hinsonville neighbors joined. His diary was silent about what interactions, if any, he had with the Walls, Jay and Cole cousins who arrived there in March. By early May, as his regiment prepared to depart for Washington, D.C., he observed his fellow soldiers' longing to heed Douglass's call "to go to the front where we can prove our love of Liberty and that we be men." As they moved through New England towns, the men were buoyed, as the citizens, many white, expressed their support and admiration of the USCTs' loyalty to the Union. Robert wrote:

I can but thank God for raising up such friends for the colored man, these people are truly our friends. Born in a border state as I was I can fully appreciate the difference between the frank open manly principle of these people and the would be Lords of the South. We are cheered in every town and village as we pass through. When leaving Readville I was surprised to see a great many white people weeping as the train moved south, and I have formed a firm conclusion that these people are our only true friends.[97]

Upon reaching Philadelphia, the men dined at the Cooper Shop Refreshment Saloon, which was welcoming to black soldiers. "A gentleman there express'd himself much pleased with the appearance of the regiment, and hoped we as men of color would win a name that will stand in our favour upon the record of our country," Robert said, noting the reminder of the USCTs' ennobled role in reshaping American society.[98]

While on the battlefront, he read scriptures daily, a continuation of his family's morning worship ritual, which provided much-needed assurance: "Read for my morning's lesson the 1st and 2nd chapters of Galatians. Have

now read the new testament this far through. Very good and instructive."[99] He wrote to and received letters from his brothers and mother and described encounters with fellow soldiers, including his classmate Christian Fleetwood, whose military accomplishments he admired: "Found my old friend Christian A. Fleetwood formerly of the Ashmun Institute now Sergt. Major of the 4th U.S. Col. troops."[100]

Amid intense combat near Rebel stronghold Richmond, surrounded by wounded and dying soldiers, an exhausted, frightened Robert pondered his fate:

> *Oh! What sorrow I have experienced through the past 12 months, but it is for the welfare of a good government and to establish a noble principle. How good the Heavenly father has been to me a very unworthy and reckless boy. During my wanderings from 1861 till now. I have thought I could [not] have gone through what I have, but I trust that I may return safe home to.*[101]

Unmounted, the 5th Cavalry was also unarmed during a period of intense fighting near Fort Monroe. Within twenty miles of Richmond, Robert observed their vulnerability under enemy attack:

> *There is a great excitement here our pickets are coming in & from the masthead of a war vessel they are watching the movements of a heavy force of rebels that lay to our rear. The 5th Map cavalry are unarmed. There are several regs. of colored troops here, with some cavalry, and artillery. 6 P.M. have had our muskets issued to us, with ammunition. The infantry are in line. I have seen one of their pickets that was killed this afternoon. He was first shot in the calf of the leg, which disabled him, then they came up to him and broke his skull with the butt of their muskets. His brains are scattered over his face and head. Can such men eventually triumph? God forbid.*[102]

Near Point of Rocks on the Appomattox on June 21, 1864, he wrote: "At 2 a.m. roused & ordered with the Surgeon to report to brigade headquarters at P.R. where we arrived about daylight. After a tiresome march the other orderly having to carry my baggage, for I could not see and the march was to[o] hard."[103] In early July, he fell ill with typhoid fever and was ordered from the ranks. The five-foot, seven-inch, light-complexioned, hazel-eyed Robert could barely stand. His mother, Sarah Ann, soon arrived to nurse

him: "Mother came on & arrived here this morning. Oh what a relief to me. I am now getting much better and can sit up and stand a little."[104]

Early August arrived with both hoping for a furlough that did not come through. Sarah Ann returned home. Robert was discharged from the post hospital in Point Lookout, Maryland, on October 4, 1864, and from army service. "Said Robert G. Fitzgerald's eye sight is very bad," noted a commanding officer, "so bad as to render him entirely unfit to perform the duties of a soldier."[105]

"Where Teachers, Scholars and Friends Were Politely Waited Upon"

The annual celebration of Hosanna Sabbath School, Rev. John Y. Hayslett, Superintendent, took place on October 1st. The day was rather unpleasant, yet, through the well known ingenuity and exquisite taste of our beloved Superintendent, it was made the happiest celebration we ever witnessed out here or in any other rural seat, and we have been privileged to attend a great many. The children met at the Church and delivered short scriptural declamations, to the encouragement of all present, after which an extensive procession was formed, and moving to a beautiful grove not far distant, we were appropriately addressed by our Pastor and the Rev. Eddie Deck. The weather becoming too inclement, the party returned to the church, where teachers, scholars and friends were very politely waited upon by a committee, from a voluptuous table, groaning beneath the weight of all the luscious dainties of a fruitful season. The church being too small for the accommodation of the mass, the commodious hall of the institute, was opened for their entertainment. There, both old and young indulged in the most innocent hilarity. Plays congenial and peculiar to such days of festivity, were engaged in by all, of which the most prominent was "Copenhagen." At 8 o'clock in the evening, the company dispersed, after engaging in a general promenade. There were a great many young ladies from Philadelphia, Wilmington, West Chester, and the surrounding villages, upon whom the young men bestowed their highest and most eloquent encomium. Certainly some of them were most exquisite specimens of the wondrous skill and wisdom of the Creator of all things.
PLATO P. HEDGES.
Ash'n. Inst'e, Oxford, Chester Co., Pa.[106]

Robert was not back in time for the annual Sabbath school celebration, which afforded—as described by his former classmate Plato Hedges, who was working at Ashmun as a tutor and within the AME circuit—the opportunity for "teachers, scholars and friends" to comingle and cultivate one another. But this nurturing community populated by Hosanna members, Ashmun students and teachers, black Methodist affiliates and relatives and neighbors welcomed Robert back home. Here he recovered and re-established himself.

A sadness soon enveloped the church, village and institute, however. James Ralston Amos, former Hosanna trustee and minister who inspired the institute's founding and was its first graduate, died in December after returning to Pennsylvania from Liberia. Plato led the effort to issue a "Testimonial of Respect" for the man whose legendary life loomed in the psyches of Ashmun students. His prayers and fundraising efforts helped establish their school, and his ministry extended to the African motherland, which many of them longed to see. Parts of the testimonial resonated with Robert's urges to continue serving his country and people:

> *Resolved, 3d. That we highly commend and admire the self-denial and missionary spirit, exercised by him, in leaving his native soil to preach the everlasting Gospel of the blessed Son of God to the perishing sons of Africa...*
>
> *Resolved, 4th. That we imitate his example, by our uniting efforts for the dissemination of religion, literature, and the principles of true morality among our race.* [107]

Contemplating his life calling, Robert re-enrolled at Ashmun the next term.

"ONWARD AND UPWARD"

As Douglass had urged black men to fight for the Union, following the war, civic, religious and political leaders urged black men to go south to serve the newly freed men, women and children. Ashmun was renamed Lincoln University in 1866 to honor the emancipator president and redirected its Liberia-focused mission to American-focused uplift. In addition to seminary training, the university curriculum began to prepare its male students for vocations that included teaching, law and medicine. At commencement that year, Major General Oliver Otis Howard, director of the Freedmen's Bureau

who became a member of Lincoln's Board of Trustees, urged students to move "onward and upward" in "elevating their race, both in this country and in Africa, but particularly in this country."[108] Robert, Christian Fleetwood and more than thirty Lincoln graduates and alumni who served as USCTs listened keenly to the revered, battle-tried general who lost his right arm fighting the war to end slavery and was now funneling funds into schools to educate newly emancipated people. By the end of the year, undoubtedly inspired by the Lincoln University model, the general met with like-minded advocates to co-found Howard University, named in his honor.

Robert had already made up his mind and was preparing to travel to Amelia Court House, Virginia, to open a Freedmen's Society school. After stepping off the train with fellow teachers into "one of the most dreary looking places you ever saw," Robert wrote to Lincoln president Isaac Rendall that August, saying he recognized former soldiers whom he saw at the Battle of Petersburg and that "they seemed to have that savage unsettled appearance, and we were somewhat alarmed to hear some of them use oaths in speaking of us."[109] Shaking off the foreshadowed danger and hostility he and Freedmen's Society teachers would face, Robert threw himself into his work. Arriving to find the intended schoolhouse without a roof, door or windows, he gathered a small workforce, labored with them for three days "nailing on the roof, carrying timber, making the floor" and opened the school with eight students on the fourth day.[110] Robert's letter revealed his pride in teaching and respect for freed people's efforts to get an education. Some walked up to ten miles to attend:

> These people learn more rapidly than any school I ever taught and if you approve of it, I shall remain on here until the first of Nov. They insist on our staying and Mr. M has made arrangements to teach our Latin and Greek lessons twice a week, & I think by that time we could have these people reading, writing and ciphering for enough to keep their accounts.[111]

Moving to practical matters, he acknowledged the balance he owed the university, which he intended to pay. His letter to Rendall suggests that his need to earn money as much as vocational calling influenced his abrupt departure from Lincoln:

> Has father paid that bill yet? He told me just before I left that he would pay the 1st thing after his crop was off in this or the first of next month? If it is not paid by that time, by him, I will have enough earned to send it

myself, and shall do so. We only get $25.00 a month and board & pay our passage home, so you can see that after buying our summer & winter clothing, paying our passage home & even 4 months pay will look very small. Can I look to come as I did last winter? In another session I hope to be able to master arithmetic, or at least the one we used last winter & then I would be able to do a great deal of good in this quarter.[112]

Robert knew completing his studies would help his career but also require financial assistance. The superintendent of the freedmen schools in the county where he worked offered him a position as principal of a high school once he graduated. "Now if there could be any arrangement made by which I could remain at the college that long," Robert suggested to Rendall, "I would be willing to refund the expense with a small interest as soon as I could earn it."[113]

By the following summer, Robert again committed to writing his belief that teaching was a divine calling. His students, mostly former slaves, inspired him:

I came to Virginia one year ago…erected a school, organized a Freedmen's Chapel School. Now have about 60 who have been for several months engaged in the study of arithmetic, writing. I must express the gratitude I feel to the Divine Being for his Providence in sparing my life yet another year and placing me in a position to benefit my fellow man. I trust that I may be always guided by his Spirit and be placed in way where I may be kept a humble and useful Christian.

Average attendance 100, over 16 year[s] and a man. William Wilkerson, nearly 100 years old whose first primer was an almanac. They tell me before Mr. Lincoln made free they had nothing to work for, to look up to. Now they have everything and will by God's help make the best of it. I feel that the harvest truly is great, but the laborers are few, and my prayer to God is that he may send more laborers to his vineyard.[114]

In August, he said farewell to his colleagues and returned to Lincoln, where President Rendall welcomed him, his outstanding bill apparently settled. He was assigned to the freshman class and intended to complete the "English Course" (classical liberal studies) while living in a campus dormitory. Since the Fitzgerald home was nearby, Robert's living arrangement may have been Rendall's requirement to ensure that he focused on his studies without distractions.

ELKVIEW STATION

We passed by Forestville and the Elkview Station, and over the great trestlework over Elk Creek that appears from the top of the bridge like a bright winding serpent through the pleasant vale. We returned after a pleasant two hours walk, by which I feel much benefited.[115]

The station near his home where Robert intended his diary to be sent in case he was killed during the war still lured him. Walking there, alone or with classmates, relaxed him and helped him think. His favored walking times were Saturday mornings and Sunday afternoons between morning and evening church services. One Sunday, he took "a morning walk to Elkview around Forestville and home," worrying about his difficulty with math and bookkeeping and that a fellow student had been "sent away from College" for neglecting his studies, a fate he feared would befall him.[116] He found encouragement one morning from the university chapel's morning service and later during a quarter Hosanna meeting at which a sermon's text drew from Psalm 80, "The Lord is a strength and a shield."[117]

But Robert's insecurities continued tugging at him. He doubted he could keep up with his classmates and considered taking another teaching job, perhaps attending another school in the South where he could study and teach at the same time. Struggling with impaired vision and concerned about not fulfilling the expectation that he graduate, he confided:

Hard at work. I was ready to give up my studies and go South to engage in the great work, of educating the millions of the South who are grossly in need of it. Mr. Rendall is not willing that I should go from here till the close of the term at which time I can get a certificate of honour.[118]

The next few months were a turning point for Robert. His parents sold their second farm near Nottingham, and he left Lincoln and began searching for a teaching job. Still grounded in his diverse faith tradition, he noted: "I had the pleasure of taking sacrament as a member of the Lincoln University Chapel of the Presbyterian Church, having joined yesterday. 8 p.m. Attended service at the Methodist Church, Hosanna. A very good time."[119]

The Fitzgeralds, including his parents, considered relocating to North Carolina, where Robert found a job teaching in Hillsboro in 1868. He invested in a brickmaking business and found time to form "the acquaintance of a Miss Cornelia Smith, a fine looking octoroon of Chapel Hill."[120] Both

color and love struck, he married Cornelia in 1869. That year, his parents sold their Hinsonville farm, purchased a farm near Durham and relocated.

"I never intended to ask the government to help me as long as I could help it," Robert stated thirteen years later in his pension application.[121] He waited eighteen years after his discharge before filing, but efforts to make a living with weak eyesight, now blindness, had failed. The man whose steadfastly independent family held its own and who told his children and grandchildren, "Never be beholden to anybody if you can help it," needed help.[122] He said an injury caused his blindness while he worked for the quartermasters in 1862, when "he was wounded in the face, the bullet entered near the left eye, breaking the rim of the bone which surrounds the eye, the ball or shot being now embedded in the bone; and that for about a week he was entirely blind in that eye."[123] Due to the absence of proof of the alleged injury, his claim was rejected. There was no record that he was treated for this injury. Even if he had been, Robert was ineligible for a pension because at the time he was a civilian employee, not an enlisted man. Medical examinations concluded that Robert's amaurosis, which had progressed with age, did not originate during military service and was probably congenital.

Fortunately, by 1890, he had become eligible due to his age, as allowed by the new law, and began receiving payments that steadily increased until his death in 1919. Cornelia received a widow's pension until her death on August 9, 1924, the same date of her marriage to Robert. Both are buried in the Fitzgerald family plot in Maplewood Cemetery near their former home, now a national historic site and center devoted to promoting social justice.

3

Comrades and Neighbors

'Reckly attuh de Yankee soldiers done come in a bulge from way somewhars downed Gulf an' brung freedom to dem what was raised unduh de whip an' lash, de po' slave 'tempt to git hisse'f togethuh an' staa't up chu'ch sevus in de Bottoms.[124]

The black Texan dialect probably sounded strange to 127th comrades Samuel Henry Blake, Amos Daws and Isaac Amos Hollingsworth, among the Yankee soldiers who "brung freedom" to their brethren, who were so informed as late as June 19, 1865. Defiant of the 1861 Emancipation Proclamation freeing slaves held by states in rebellion, some owners fled to Texas, joining others equally determined to keep their human property. Following General Robert E. Lee's surrender at Appomattox in April, the 127th was sent southwest to Texas with other troops, where it was stationed near Galveston, the former port town of Brazos Santiago and then Brownsville, near the Mexican border. Between then and October when they were mustered out of service, Samuel, Amos and Isaac worked under harsh circumstances that would affect their health for the rest of their lives.

The three had lived as free men and neighbors before the war and understood their duty, however harsh, to liberate those who had not known the same freedom. They endured. Amos Daws never fully recovered from the chronic diarrhea he said he got "from drinking salty water out of a sand hole" under a "sun hot enough to nearly roast eggs" while on guard duty near Galveston, where provisions of water were limited. He, Samuel

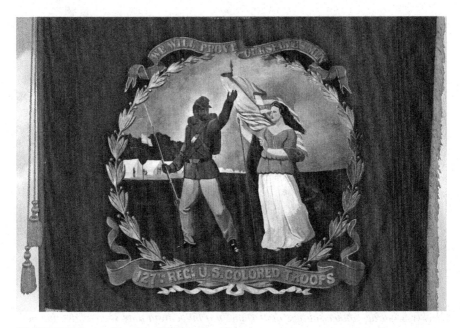

127th USCT flag replica. *Camp William Penn Museum.*

Blake and Isaac Amos Hollingsworth recalled how some soldiers stricken with chronic diarrhea died and that sleeping near chilly, damp rivers caused rheumatism and other ailments—the unacknowledged costs these soldiers paid while they "brung freedom."[125]

SAMUEL HENRY BLAKE

"The Old Man Would Be in the Poor House"

The most documented details about Samuel Blake indicate that he was physically disabled after serving a year in the army and died in poverty. Discharged in 1865, he did not apply for a pension until 1881, and by then, his health was failing. He could not work a full schedule yet was trying to support himself, his wife and a son. Desperate, he turned to Theodore Stubbs for help. A Pennsylvania state representative and Oxford attorney who specialized in filing veteran pension claims, Stubbs was the go-to man for most Hinsonville men seeking compensation for their army-related injuries and, later, disabilities brought on by aging.

Family physician Theo A. Worrall of North East, Cecil County, Maryland, initially examined the sixty-year-old Samuel, describing him as six feet tall, weighing 150 pounds and of dark complexion. Worrall concluded that the "wound to the top of [Samuel's] head which breaks into a sore in warm weather" was caused by artillery shell and that pains ailing him in the "calf of the left leg and injuries to the right side, left shoulder and breast" occurred during combat duty.[126] But his findings, mostly based on Samuel's descriptions of his injuries and how he got them, were not enough. The bureau required more proof, including accounts from his comrades, which were eventually deemed speculative or inconsistent. Samuel's insufficiently supported claim and Stubbs's questionable ways of securing evidence for his clients prompted a special investigation. The arduous effort to secure a pension lasted nearly eight years, foreshadowing Samuel's sad fate.

Forty years old when he enlisted for one year on August 22, 1864, Samuel was a farm laborer living in New London Township with his wife, Margaret, and daughter Mary. Born in Cecil County, Maryland, Samuel had been living in New London as a free man since at least 1860 and would reside in the area for most of his life. Margaret died in August 1875 and was buried in the Hosanna Church Cemetery; within two years, Samuel partnered with Rebecca, who bore a son they named Samuel. The newly formed family, which included eight-year-old stepson Alvanus Moore, made their home nearby in London Grove.[127]

Despite surgeon Worrall's certification in 1881 that qualified Samuel Blake for a pension (four dollars for head, two dollars for leg and two dollars for shoulder), his claim was declined. Undaunted, Stubbs initiated more applications. Writing in November 1884 to the pension commissioner on his Pennsylvania House of Representatives stationery, he urged a timely review of his aging client's case:

The old relic of the late war Samuel H. Blake B 127th USCT Claim No. 346927 still survives through suffering severely from his ravine across his head where the shell ploughed the scalp off and limps around with his hole in leg and around breast a surprise to pension advocates. If there is any way to push his claim or call it up so he can have justice done to his merit please advise me soon and oblige to Theo K Stubbs[128]

A few weeks later, Samuel submitted a statement describing when, where and how he was injured. D.A. Stubbs, business partner and brother of Theodore, notarized Samuel's summarized statement, which contained

dates and places appearing to coincide with the 127th's movements at Appomattox, Petersburg and Dutch Gap, Virginia:

> *The alleged injuries to my right side and breast were received on the Appomattox and the circumstances of their origin were that we were marching from Clover Hill near Appomattox back to Petersburg, VA after Lee's surrender about April 11, 1865 along with artillery when one piece sank through the corduroy road into mud. In prying it out a lever threw me against a stump and hurt my left shoulder. It shurted me around and strained and wounded my left side and breast. The misery started in the shoulder and lodged in the breast. I had been struck with shell at Dutch Gap and shot in leg at Petersburg before the above injury was incurred. I was under a tree close to hospital for four days and there were so many crazy torn up men about that I got sticks and hobbled back to Regiment at City Point.*[129]

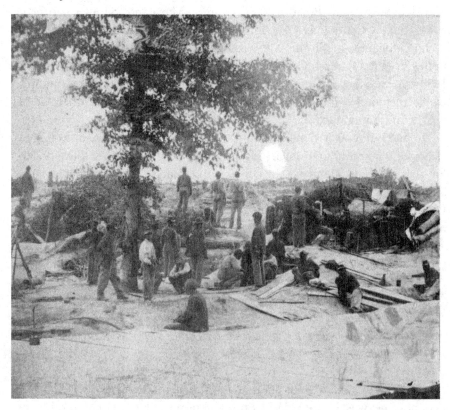

USCTs at Petersburg, Virginia. Samuel Blake said he was shot in the leg while here, an injury that caused a permanent limp. *Library of Congress.*

Henry Carl, who served with Samuel in the 127th, backed him up, saying his comrade and longtime acquaintance was able-bodied and healthy before enlisting:

> *I was with him in the same camp when he was injured with a shell in head, leg and left breast. I saw him after he was in hospital and heard comrades talk about him getting wounded so badly at that time. I have known Samuel Blake for more than 25 years. I worked with him many a day and he was sound before he enlisted and his head and leg affect him since discharge.*[130]

Appeals to the regional Pension Board in Philadelphia continued into the next year. Bunkmate Amos Daws had known Samuel for nearly forty years and provided an earlier statement verifying the injury claims and asserting that he attended his disabled mate. At this stage of their lives, aging veterans like Amos knew the formalities of pension rating language and signed the summarized statements placed before them. Weary from declining health and ability to earn livable wages through physical labor, they knew firsthand how hard securing a pension could be. And even when they managed to, it was not enough. Having seen comrades and friends starve and die, they helped one another out when they could:

> *In addition to my former testimony I would state that the injuries of claimant to side and breast and leg and head contracted in service were such as to contract permanent disability and to prevent him from going on duty for a long time and make him worry and complain nearly all the time and that by reason of his injuries incurred in the service and in line of duty in army he is now about five sixths disabled from manual labor and was one half disabled from 1870 to 1880 ¾ from 1865 to 1870.*[131]

Samuel "is now only able to move around not able to work scarcely any and the old man would be in the poor house if a kind old Quaker did not give him a house to be until he gets his pension," Amos said.[132] The October 1885 appeal to the pension commissioner was his near-final plea for mercy. Anticipating his impending death, Samuel tried to secure funds to cover his upkeep and burial costs:

> *I am getting in a very desperate way, as winter comes on, and something must be done or the old soldier must go on the County. I have filed proof in my case, Samuel Henry Blake No. 346927 B 127th USCT and am*

wounded in right breast, right side furrowed head, with shell…have hole through left leg, bullet wound. Have proved I was ¾ Disabled 1865 to 1870, ½ disabled 1870 to 1880, ⁵/₆ to full disability from 1880 to present time. I am past 3 score and 10 played out poor and have to live and can't work. Please send me back my discharge. We have a law in this state to bury old soldiers at expense of the County and my wife might need the discharge. If I have not proved all my wounds satisfactory allow me pension on part, and I will be able to pay a man to hand me to the squires so I can prove the others if I live a few months longer. Please answer soon and oblige.
Samuel H. Blake.[133]

Similar urgency resounded in Stubbs's letter to the commissioner:

We have a tall old man hobbling around here at times, with a plain furrowed, scabbed head, bare and self-evident; his right shoulder hanging lower than natural, and very perceptible mark of a bullet square through left leg. It is a mystery to many, why a soldier torn up like him, has no pension for at least part of his disabilities, any one of which would prevent his livelihood from manual labor. Please call up his case and oblige him & his friends.
Very Truly T Stubbs, Oxford[134]

By now, though, the commissioner had received reports of Stubbs's questionable practices and not-so-valid claims submitted. Samuel's claim was referred to special examiner Charles Mays with instructions to thoroughly investigate suggested criminal activity. In January 1886, Mays began interviewing witnesses, including Amos I. Hollingsworth, Stephen Ringgold and W.C. Powell, an army physician who was assigned to the regiment field hospital during Samuel's tour of duty.

Amos Hollingsworth had signed an earlier statement that Samuel was wounded in Dutch Gap around November 1864, when "a shell struck a tree about one foot in diameter cut the tree clear off and either a piece of the shell or a limb of the tree struck Blake on the head knocking him senseless."[135] He also "heard Blake complain of a sore left side being struck with a cannon and said it nearly killed him" in early April 1865 near Hatchers Run, Virginia.[136] But later under Mays's probing questions, Amos said he only noticed Samuel's wounds after they were discharged and had no direct knowledge of how they occurred.[137]

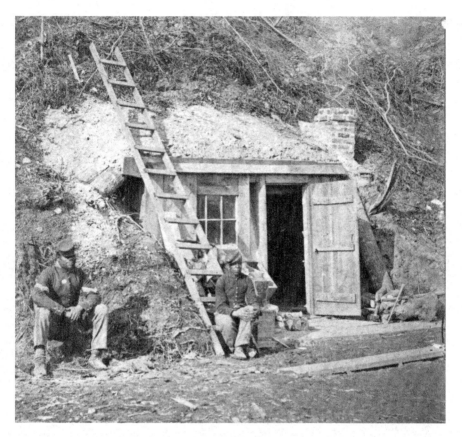

USCTs at Dutch Gap, Virginia. Many soldiers reported incurring injuries here, both from detail duties and enemy fire. *Library of Congress.*

Mays instructed Samuel's neighbor Stephen Ringgold, who served in the 22nd, to describe the circumstances under which he signed a previous affidavit Stubbs provided. Stephen's answers divulge evidence of likely manipulation of facts supporting Samuel's claim:

> *Q: State the circumstances under which you made the first* [affidavit] *one in lawyer Stubbs' office.*
>
> *A: Blake himself came to me one day when he was here and asked me whether I would sign a paper that I personally knew him and I went with him to lawyer Stubbs' office and signed an affidavit.*
>
> *Q: What did the paper contain that you signed?*
>
> *A: That I couldn't say for all Oxford. The paper was read. There were several persons in there when I signed it.*

Q: *Were you asked any questions by anyone?*

A: *Yes. I was asked by Blake if I didn't remember about his wounds. I laughed it off because I didn't recollect.*

Q: *Did lawyer Stubbs ask you any questions?*

A: *I believe he did ask me some, whether I knew Blake in the army. And how soon after I came home it was that I saw him. And he questioned me closely as to what I knew about his wounds. I told him I didn't know him in the army. That I saw him six months or so after I came home and that I knew nothing about his wounds, only as he told me. I heard him talk about a wounded leg and having a scar on his head, but I never saw them and told Mr. Stubbs.*[138]

Mays then asked Stephen to examine the document on which he signed his full name. Stephen recognized his signature but not the type of paper:

Q: *Who was in the room at the time?*

A: *Blake and myself and lawyer Stubbs and his brother.*

Q: *Who wrote the affidavit you signed?*

A: *I don't know. The paper was already written when I went in.*

Q: *Did you take the paper up and examine it?*

A: *No*

Q: *How did the person who wrote the affidavit know what you would swear to?*

A: *I couldn't say.*

Q: *After having heard read to you the part of the affidavit attributed to you, what do you say as to whether you would swear to it?*

A: *I would have sworn that he said soon after I met him when I came home that he was wounded in his leg and head, but I couldn't have sworn to his being lame or disabled because I never worked with him.*

Q: *Are you willing to swear that the paper I have shown you is not the paper you signed in the notary's office?*

A: *No sir. While I am of the opinion that it is not the paper I signed, yet I am willing to say that it may have been so folded when I signed it that I didn't notice the pasted part. There was a lot of other papers laying on the table at the time.*[139]

Physician W.C. Powell's deposition did not support Samuel's injury claim. In fact, Powell had no record of treating him for said injuries:

Q: He also says that about April 2. 65 at Petersburg VA he was wounded in one of his legs. Do you remember?

A: I do not remember the case....I remember on one occasion in Nov. or Dec. 64 it was deemed necessary to fell trees near Signal Hill VA in order to get range for the cannon and men were put to cutting the timber. Trees were falling all about them and some were struck by limbs of falling trees. I was called to treat some half dozen of them—none were serious. All were scalp wounds. No skulls fractured. I don't think any of them were sent to hospital. Nor do I recollect this particular man as one of them.

Q: He says also that he was hurt while moving a gun about April 65?

A: I don't remember him at all [referring to a special examiner to surgeon in New York in possession of a hospital register, a prescription book covering from enlistment to January 19, 1865].

Q: After reading claimant's several statements to you, do they recall any recollection of him?

A: No, they do not. The statement about my probing his leg and calling him a "damned hard-headed fellow" is not so. There were none wounded about April 1 or 2 1865 by Minnie balls, we were exposed to shell and mortar firing only. I have the Regiment hospital record from January 19, 1865 to March 25, 1865 and his name does not appear at any time.[140]

Mays concluded his investigation, noting that in the case of Samuel Blake, the Stubbs brothers "have endeavored to strengthen an otherwise weak claim by getting ignorant and careless men to sign affidavits setting forth more than the affiants actually know," an apparently common practice at the time, and recommended "in view of their mode of obtaining evidence, that all claims in which they appear, either as notary or attorney, be closely scrutinized."[141] His report provided details of how the Stubbs scheme worked:

D.A. and T.K. Stubbs have their offices adjoining and opening into each other. They transact business in either room and have a large pension practice. On careful inquiry, I learn that though no particular criminal acts have been laid at their doors, they are regarded as not above suspicion. T.K. Stubbs has spoken to others of his general success in prosecuting pension claims that had failed in other hands, and said that "claimants as a rule were liberal in their payments and frequently made presents." I have no doubt but they do intimate to pensioners that any additional sum to the fee

*would be accepted, or that they might give "so and so" as a present. But
without the names of parties who have had claims allowed, it would be
next to impossible to get at the facts, unless some should complain of the
practice.*

*That they have drawn up and filed with this claim affidavits that are
not borne out by subsequent statements of affiants is without question.
But there appears to be considerable doubt among the affiants themselves
as to the manner and form in which the affidavits were drawn. They all
admit some knowledge by hearsay of one or the other of claimants alleged
disabilities, and all acknowledge their signatures.*

*That T.K. Stubbs has been guilty of acting as a notary in swearing
affiants and D.A. Stubbs of affixing his signature and official seal to
papers to which he had not qualified the affiants, I have no doubt. But [do]
not think sufficient evidence could be procured, either against the Stubbs or
the witnesses.* [142]

"The Poor House"

Less than four years after Samuel foresaw having to "go on the County,"
he was admitted to the Chester County Poor House in Embreeville. The
January 24, 1889 roster listed Samuel "Blakeley" as a sixty-year-old black
man unable to read, not able-bodied and widowed, an apparent reference to
his late first wife. He died there less than three months later. [143]

In 1891, the same year Rebecca filed for a widow's pension, the bureau
affirmed its rejection of the deceased Samuel's claim, based "on the ground
of no record of causes alleged, and the inability of the claimant with aid of
special examination to establish the origin of causes in service and line of
duty." And Samuel's observable physical disability, "the abnormal condition
of head," the Pension Board doctors opined, was "not a result of fracture
of the skull, but it is a natural congenital deformity." [144] Under her maiden
name, Rebecca Taylor was represented by a Washington, D.C.–based
attorney. Samuel's second, and apparently common-law, wife filed a claim
and several appeals. But her claim was rejected because the Pension Bureau
did not consider her a legal wife or widow:

Madam:

*Your claim for pension as widow of above named soldier was rejected June
20, 1898 on the ground that you are not the legal widow of soldier, as*

A Grand Army of the Republic medallion marks an unidentified Civil War soldier's grave at Hosanna Cemetery. *Author's collection.*

shown by your own statement to special examiner that there never was any marriage between you and the soldier.[145]

A year after the 1910 census listing Rebecca Taylor, seventy-two, a black, single servant, living in Oxford on Boot Street, she died from cerebral hemorrhage and was buried in Chestnut Grove Cemetery in West Chester. Though not acknowledged by the Pension Bureau as Samuel's legal wife, she was officially recorded as Rebecca Blake upon her death.[146]

The Hosanna grave to which Samuel Henry Blake went, never having received a disability benefit, is unidentifiable.

AMOS DAWS

"I Saw Him Drunk a Week Before His Death at a Party in His House"

Amos Daws preceded his friend Samuel Blake in death by three years. Like Samuel's grave at Hosanna, Amos's is unmarked. Yet while his resting space may be forgotten, his story of negotiating a life of loss, love, illness and more loss was memorable.

He worked hard and drank heavily while employers and neighbors admired his ability to balance the two. He could be bad tempered, though only when drunk. He was a devoted husband, father and stepfather who died at the age of fifty-three due to war-related illnesses and, of course, hard drinking. Some said Amos drank himself to death, which was partly true but not the whole story. Coping with sickness, bodily pain and loss of people he loved, Amos Daws decided to live fully while he could.

Standing five feet, eight inches tall, Amos weighed 180 pounds during his best years before he became a soldier and was a sought-after farmhand. "I knew him to be one of the best hands in Elkdale, Oxford before he enlisted," said Amos Hollingsworth, who shared his comrade's first name and was stationed with him in Texas in July 1865. While on guard duty on an island near Galveston, Amos became ill from "drinking salty water out of a sand hole" and "with sun hot enough to nearly roast eggs"; at night, when the men "lay between two rivers, it would be damp and chilly which gave him rheumatism," he said, repeating his comrade's claim.[147] Hollingsworth says he saw Amos contract "severe disease which struck him in his hips then through the bowels and turned into chronic diarrhea and rheumatism," like "a great many [who] died of the same there."[148]

Amos got better but never fully recovered. Within a year after leaving the army, most of his teeth had fallen out, his bowels were uncontrollable and his back and hips ached. Like many Civil War soldiers, he was afflicted with scurvy, chronic diarrhea and rheumatism, for which he eventually received a pension, but much later. Often ill and unable to work, Amos did not apply for a pension until 1881. After his 1865 discharge, he tried medicinal remedies, drank whiskey to numb his perpetual pain and kept moving, determined to support himself and his family. "I am very ambitious and proud or I would have [had] to be kept," he said.[149]

Little is known about the early life or origins of the veteran, who told examining physicians and his lawyer, "I had my health ruined in the hot sands and swampy bayous of Texas."[150] But his work habits, which he deftly recalled, and his Chester County residency were documented and consistent. Daws's lifestyle before 1865 was stable. Service to his country destabilized him. For fifteen years before enlisting, he lived and worked in Chatham, Landenberg and New London. "I was around, at and near New London in Chester County, Pennsylvania, nearly all my life," he said, trying to resume working despite his disabilities.[151] Amos's detailed work history revealed his relationships with several landowning families, black and white, who readily employed him:

For 5 years before enlisting August 26, 1864 I lived with John Ross Chatham Chester Co. PA. Samuel Hughes same P.O. and Evan Browns Landenberg Chester Co. PA. Worked on a farm since I came home from War Sept. 8th 1865. I lived with Willie Eves 2 yrs and Harvey Hutchinson 4 yrs New London P.O. Chester Co. PA. Thomas Fisher 2 yrs Calvert, MD. James W. Hutchinson 4 yrs Oxford P.O. Edward Walls 3 yrs Lincoln University Chester. Co. PA. Harvey Hutchinson New London Chester Co. PA 2 yrs. These people were my landlords and I worked for them when I was able [bodied] *occupation day laborer.*[152]

By the time Amos filed this claim, he was barely able to work: "The rheumatism worries me most now. I couldn't hire by month. If I work one day, then I must lay by."[153]

Born and raised in Pennsylvania, Amos was first married between 1858 and 1859 to Julia Crosby from Chesterville, Pennsylvania, who died before he enlisted. They were married for only a year. After his term of service, he lived for three years with Anna "Annie" Palmer, widow of Civil War soldier Jacob Palmer, who died in Deep Bottom, Virginia. Amos and Annie eventually married in 1868. For those three years, insisted Annie—who at the time received a pension for her late husband, Jacob—she kept house for and nursed Amos and was not his lover prior to their marriage. Four years after his July 11, 1886 death, Annie applied for a widow's pension and provided testimony revealing more details about Amos's and her life and their relationships with people in Chester County and neighboring Cecil County:

When he came from the army he visited me, and it was the first place he stayed. I was then on the Thomson place in Cecil Co. Md. near Heilman's [Hellman's] Tavern. He was sick then with a terrible cough and diarrhea and remained with me all that winter, and when he got better he went to New London Chester Co, Pa. where he belonged before enlistment. Dr. Turner, deceased, who resided in "Brick Meeting House" Township Cecil Co. MD treated the soldier during the winter of 1865–6 and spring of 1866 for cough and diarrhea. He got a house in 1866 in the fall at New London and I was up there with and lived with him and kept house for him up to the time of our marriage in 1868. I was not living with him as a wife but as house keeper prior to our marriage. I had no children by him until after our marriage.[154]

Old Hellman's Tavern, later Nottingham Tavern, sits on the Maryland and Pennsylvania state line. Amos and Annie Daws lived nearby and collected their mail here. *Library of Congress.*

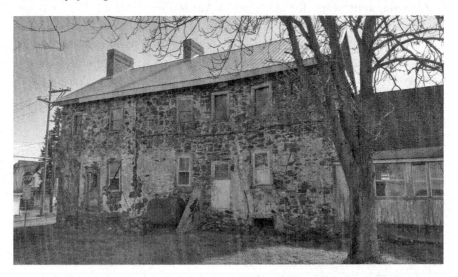

Current view of Nottingham Tavern. The abandoned tavern is a popular landmark. *Author's collection.*

The Hellman Tavern Annie described became the Nottingham Tavern, which sits on the Maryland and Pennsylvania state line and is a popular landmark.

Upon further questioning, Annie revealed how she knew Amos and why he sought her out after he returned to the area. They are related: "Any of the colored people hereabouts can give you this history of my husband while he resided here. I was his first cousin and that is how he happened to come to my house immediately after his discharge."[155]

First cousins Amos and Annie married on December 24, 1868, in Oxford. He worked as a farmer, and the couple reported real estate and personal property worth $400. Their combined family included three biological children, Rebecca, Josephine and Henry, and stepsons Theodore Palmer, George and William. By the time Amos and Annie moved back to Hinsonville, his health had gotten worse. In 1880, he reported being unemployed for at least five months and soon applied for a pension.[156]

"Daws Drank Himself to Death"

Pension investigators often checked for "vicious habits" like alcohol abuse or smoking that may have caused illnesses among veterans—a moot point for hard-drinking Amos, who had applied for and received pension payments. Still, West Grove neighbor Ida Kyle, who had known him since her childhood, as he was a close friend of her late father, provided testimony to support Annie's pension request that revealed more details about Amos's lifestyle:

> I always understood that Daws drank himself to death. He was drunk a good portion of the time. He kept whiskey in the house when he could get it. I saw him drunk a week before his death at a party in his house. I often saw him so drunk he could not take care of himself. He would go to Oxford and get drunk and stay out all night. He was locked up in Wilmington Delaware for drunkenness. I am not a prohibitionist but I do not use intoxicants. I am and always have been on good terms with the family.[157]

Despite his drinking habits, Amos's reputation as a reliable worker persisted, as J.M. Hutchinson, a member of a black landowning family in New London whose father once employed Amos, noted:

He worked for my father by the years and I worked with him. He was considered a good able-bodied hand. I can't say his health was good at all times, although he was a strong built man. I can't say what was the matter with him. He was a drinking man but don't think he abused himself while he lived on our place. He was a steady hand while here and only drank on special occasions. My father paid him good wages and employed him by the year.[158]

But it is Amos Hollingworth's additional testimony that hinted of some root causes of or circumstances that contributed to Amos's heavy drinking habits. "He drank hard all his life," Hollingsworth said. "This is all he was raised by Ellison [probably Eliza] and Henderson McDowell of Elkdale PA," owners of a large mill business who employed free blacks.[159] Hollingsworth's phrase "raised by" suggests that Amos from a young age did not live with his biological family or relatives but instead with the McDowells and that he began drinking early, likely by the example they set for him. The people around him drank, so he drank. "This is all he was raised by."

Rebecca Daws and Henry Kinslow marriage license. Isaac Rendall, Presbyterian minister and president of Lincoln University from 1865 to 1906, conducted the ceremony. *FamilySearch.org.*

Raised without parents and widowed after a brief marriage, other losses marked Amos's life. Four of the five children born to him and Annie died young. Their surviving daughter, Rebecca, married Henry Kinslow on May 20, 1886, less than two months before her father, who consented to their union, died.

"I Now Ask for Pension as His Widow"

When Annie applied for a widow's pension three years after Amos died from consumption, her benefits as Jacob Palmer's widow had expired, as each of the children from that marriage had reached sixteen—although there may have been some unreported overlap. Though well supported by credible witness statements, the office rejected Annie's application, namely because Amos Daws left no minor children.[160]

Amos's death was sudden, though not unexpected, given his health. Despite the loss of his first wife, diseases caused by military service worsened by heavy drinking and the deaths of four children, Amos endured. Longtime friend and neighbor Lydia Hickman, with whose family Amos once boarded, recalled his persistence:

> The soldier had been drinking a little when he first came...after the war. He got over that [and] went on to work. They can tell you in Lincoln he always drank and got on sprees. I have got up and let him in many a night when he was drunk. He did not lose much time in that account. He generally got on a spree every Saturday night and would go work on Monday morning.[161]

ISAAC AMOS HOLLINGSWORTH

Buried in His Own Suit

Funeral director Oliver Blair received the corpse of the soldier from University of Pennsylvania Hospital on Monday, November 12, and immediately began preparations so that it would be ready for the Tuesday afternoon train to Lincoln University, Pennsylvania. Amos Hollingsworth's widow, Mary Jane, and daughter Clarissa Draper had carefully conveyed the

details of handling his body to Blair. Amos's death was expected. Gravely ill, he had been under care at University Hospital for twenty-one days before he passed.

After embalming, he was dressed in his finest white collared and cuffed shirt, tie and underwear and ready for burial in his "own suit." He was laid in a silver-handled, lined casket to which a silver plate inscribed with *Amos Hollingsworth*, the abbreviated version of his name he most often used, was affixed. The total charges of $56.15, to be paid in cash upon arrival at Lincoln University Station, included $55.00 for preparation and the $1.15 railroad ticket for corpse and portage to the Broad Street Station for the 4:32 afternoon train on Tuesday, November 13. The body of the sable soldier who donned the blue uniform to unify his country was destined for "Hosanna AUMP Colored" Cemetery.[162]

An eighteen-and-a-half-year-old from Nottingham, Pennsylvania, who said Maryland was his birthplace enlisted as a substitute for George Birdsall Passmore on August 19, 1864, for three years of service. His enlistment and pension files described him as mulatto. Amos's longtime neighbor Passmore was a white, married thirty-year-old schoolteacher and Quaker. Since substitutes could not receive the standard bounty, Passmore probably paid Amos or otherwise compensated him.[163]

More than a year later, Amos returned home, suffering from chronic diarrhea and other ailments for which he would later draw a pension. He soon married and began a family:

> *Isaac Amos Hollingsworth of Kennett Township, PA and Mary Jane Harris of Lincoln University, PA were by me united in the bonds of marriage, at New London, PA, on the ninth day of December in the year of our Lord One Thousand Eight Hundred and Sixty-nine, conformably to the ordinance of God, and the laws of the State of Pennsylvania, and the usages of the Presbyterian Church. Robert P. Dubois, Minister of the Gospel.*[164]

Recurring descriptions of Amos as mulatto and references to Maryland as his birthplace are hints of his origin and relationship to area families. Although estimations of his birth year varied, Amos appears in 1850 as a nine-year-old with his parents, Moses and Harriet, and siblings in East Nottingham, where the family had lived as free residents since at least 1840. The presence of several white Hollingsworth families in immediate and nearby neighborhoods and white and free black Hollingsworths in upper and

Isaac Amos Hollingsworth voluntarily enlisted on August 19, 1864, for three years as a substitute for George B. Passmore, who likely paid him. *Fold3.com.*

central Cecil County suggests familial relationships. Family structures of people who had been enslaved or were descendants of slaves were complex due to displacement, separation through sales, death or intermarrying. The Hinsonville veterans born in Maryland or Delaware, mulatto, brown or black, were likely descendants of enslaved parents and grandparents. Also, the recurring name "Isaac" suggests that Isaac Amos may have been a descendant of the free black Isaac Hollingsworth, who in 1830 lived in the northeast corner of the county bordering Pennsylvania and Delaware and later near Chesapeake City. One of Amos's sons, Isaac, so named in the 1900 census, seems to have been the namesake of this ancestor.[165] Cecil County, where black Hollingsworths still reside, appears to have been the place of origin of Amos's family.

"This Man Is Not Able to Do Continuous Hard Work"

Amos filed for a pension in 1891, reporting numerous disabilities and ailments, including rheumatism, throat trouble, malarial poisoning, diarrhea, piles and back sores.

By then, the forty-nine-year-old farm laborer was in constant pain and only able to work part time. The examining physicians noted that the five-foot, nine-inch, 152-pound patient experienced rheumatic pains in his back and shoulders that increased in damp weather and almost constant diarrhea, with "3 to 10 stools per day," but dismissed the other claims and issued a partial rating for compensation.[166]

His additional filing in 1894 for the same ailments compelled the examining physician to recommend a benefit that had yet to be approved, reporting: "This man is not able to do continuous hard work."[167] Like

his fellow veterans, Amos was assisted by the Stubbs attorney/notary public team and soon submitted a statement describing his service-related disabilities. His partly summarized, partly dictated statement revealed that Amos had received treatment for the claimed ailments for years:

> *Statement disability is due to Rheumatism, malarial, sore throat contracted in the service and in line of duty down in Florida Jacksonville just before it froze up in 1864. Awful windy. Got rheumatism. The lame back contracted at Deep Bottom, VA about Oct. 1864 carrying heavy timber. Got diarrhea and malarial in Texas in 1865, Brazos Santiago. Have piles sometime and malarial poisoning. Since discharge, have been receiving treatment from Dr. Martin Georgetown, Lancaster, PA. Treated me for malaria, sore throat and rheumatism. He is now dead. Dr. Joseph Dickinson, Parkesburg, Chester County, doctored me. He is also dead. Dr. J.W. Houston and Doctor Truman Coates. Since original claimed disability, I have suffered with the following…results that I incurred in the war and bothered me ever since. Dr. Martin and Dickinson as above. Houston and Coates. Number of times I have been confined to bed. Two weeks or more at a time. Then in the house a month or so at a time. Always Suffering pain better or worse. I. Amos Hollingsworth.* [168]

After more applications and surgeon recommendations, Amos began receiving an eight-dollar monthly pension in 1902. That same year, a surgeon recommended the payment be increased to ten dollars, noting that Amos had long-documented ailments: rheumatism (ten years), disease of heart (fifteen years), lumbago (pain in muscles and joints of the lower back, twenty-five years), disease of throat and affection of back and left side (twelve years), malarial poisoning in service and diarrhea (twenty-five years) and general disability (twenty-five years). The recommendations resubmitted in 1903 and 1905 were declined.[169]

Two days after her husband's funeral, Mary Jane filed for a widow's pension that was eventually paid. In the meantime, the Pension Office issued her a twenty-four-dollar check for three months (eight dollars each) due Amos from November 4, 1906, to February 4, 1907. Pension checks were issued on the fourth day of the month.[170]

In a chilling after note, Amos's most recent and last physician stated that he sent his patient to the University of Pennsylvania Medical Hospital in August, where he was diagnosed with cancer of the stomach:

Isaac Amos
Hollingsworth grave site
at Hosanna Cemetery.
Author's collection.

I attended soldier during his last illness and he died November 5th 1906. He had been under my care since August 15th 1906, suffering with cancer of the stomach. I later sent him to the Hospital of the University of Pennsylvania where he was under treatment for 21 days previous to his death. He died Nov. 5th 1906 of starvation and exhaustion due to inability to retain food. Dr. S. Clifton [Beals?] West Grove, PA[171]

For years, Amos had been treated for diarrhea, not for what was or had evolved into something deadly. Only twenty-one days before his demise, he was diagnosed with what had been killing him: stomach cancer. Buried near Hosanna's east side, Amos's grave site is visible and decorated. In 1922, Mary Jane Hollingsworth, seventy-one, joined the man to whom she was married for thirty-seven years.[172]

4

Free Men of Free Will

We Did Not Falter.[173]

I n September 1864, William Fitzgerald and Abraham Stout enlisted
in the 41ˢᵗ, the regiment destined to help corner General Robert E.
Lee's Confederate army near Appomattox, Virginia, and force its
surrender.[174] William and Abraham shared other similar experiences.

Before and after their army service, both free-born men moved around
often in search of jobs. Perhaps they also sought to satisfy a curiosity about
a society shifting from allowing black people to be held as slaves toward a
more inclusive democracy implying that equal rights would be extended to
black men who fought to keep it whole. Exposed to the war's deadly violence
and shaped by the dynamics of the urban and rural communities where they
lived and worked, William and Abraham were among the least-consulted
eyewitnesses to shifting regional and national social landscapes during the
nineteenth and early twentieth centuries.

WILLIAM B. FITZGERALD

"He Eventually Divorced His Wife and Was Finally Absorbed into the White Race"

The eldest of the three Fitzgerald brothers, William was affectionately called
Billy. His brother Robert had recently received a large contract to make bricks

for a penitentiary and urged him and Richard, the third brother, to come to Durham, North Carolina. Robert and their parents purchased farms there and were mostly happy and determined to make due, although they often witnessed and faced threats of racial violence. In 1869, the Ku Klux Klan lynched a black man and threatened to destroy the freedmen school Robert ran. But Robert was not backing down. Nor would Billy. The last time he visited Durham, a storekeeper asked him and Robert in front of a crowd of white farmers, "What'll you folks do down there if the Kluxes pay you a visit?" The brothers endured deadly battles with Rebels during the war and, like many black veterans, faced a continuing war with white hostility. William hitched up his suspenders and told all of them within hearing distance, "I don't reckon there's much we can do. We don't have more'n nineteen or twenty guns and a few rounds of ammunition. But I tell you one thing, if the Ku-Kluxers do come they won't all go back. They'll leave a few behind."[175]

Though not keen on returning to the South, William agreed to support Robert's venture and brought along his wife and young daughter. He commenced making bricks to fill the order, with no salary. Richard joined the effort under the same arrangement. The three brothers were making progress, but heavy rains and flash floods rushed in and damaged the kiln and bricks, washing away months of work. In June 1870, William prepared to head back to Pennsylvania, disgusted and broke.

The firstborn of Thomas and Sarah Fitzgerald, William had been making bricks since his teens. While his parents and siblings remained in Hinsonville, where the family had moved in the 1850s, William returned to work in Wilmington, Delaware, the clan's hometown. He lived at 1029 Front Street (today Martin Luther King Boulevard) near the Christina River in the city's 1st Ward with his cousins Kenny and Burton Valentine, also brick makers. William was working as a brick mason and farmer when he registered for military service in 1863 and enlisted in September 1864 in West Chester, Pennsylvania, for one year and a one-hundred-dollar bounty. The five-foot, ten-and-a-half-inch free-born mulatto man from a landowning family impressed the recruiting officer, who assigned him the rank of corporal, which meant William would oversee a small group of fellow soldiers. A supervisory officer later scoffed at this, noting the recruit "never did duty," called the corporal rank an "imposition" and reduced William's rank to private. Either William or some conscientious officer appealed that decision, and the free-born soldier was paid at rank of corporal from December 31, 1864, to February 6, 1865. William was honorably discharged after serving for eleven months and twenty-nine

days. Like many of his 41st comrades, he was owed back pay and the one-hundred-dollar bounty that enticed them to enlist.[176]

After the failure of Robert's brick business, William was disenchanted. A lot weighed on the twenty-eight-year-old veteran. How was he to make a living in a postwar society where racism was re-emerging? He had a young child and another one coming. He soon parted ways with his brothers and parents, who remained in North Carolina, and returned to Pennsylvania, where his decisions would permanently alter his relationship with them, his wife and daughters. William's great-niece Pauli Murray sums up the ominous shift in her relatives' lives:

> *Billy had neither the idealism of Robert nor the business tenacity of Richard. Nor had he the tenacity for enduring the lot of the Negro, which after a brief triumph, grew more uncertain in those postwar years. Back in Pennsylvania, he eventually divorced his wife and so far as anyone could tell was finally absorbed into the white race.*[177]

By July 1870, William; his wife, Charlotte; their two-year-old daughter, Matilda; and newborn daughter, Emily, had resettled in Lower Oxford, where he resumed brickmaking. His personal property was valued at one hundred dollars. Sometime later, William and Charlotte's marriage collapsed, and their family life disintegrated. Twenty-three-year-old Charlotte, who could neither read nor write, disappeared from the public record after 1870. By 1880, Matilda and Emma were wards of the segregated colored division of the House of Refuge in Philadelphia, Emma unable to read or write. Known for its strict regimen of basic educational instruction, the House of Refuge also conducted "moral retraining" on the children placed there because of neediness or court order. The fate of the two Fitzgerald girls is unknown.[178]

While William's estrangement from his relatives fueled speculation that he passed for white, his identity and whereabouts are traceable. Between 1884 and 1890, he lived in North and South Philadelphia neighborhoods and worked as a brick maker. In 1885, he lived in Prosperous Alley, one of the city's predominately black neighborhoods known for its crowded, substandard conditions, which sociologist W.E.B. Du Bois studied to show the negative effects of imposed racial segregation.

William's health was failing in 1890 when he told the veteran census taker that he served as a corporal in the 41st Company A—service and rank he recalled with pride. Three years later, on February 16, 1893, the fifty-four-year-old veteran, who never applied for a pension, died of heart disease. His

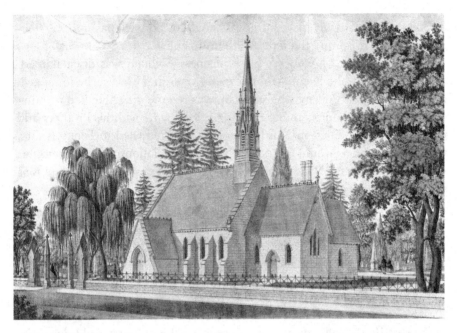

Chapel of Lebanon Cemetery reserved a section for black Civil War veterans like William Fitzgerald, who was originally buried here. *Historical Society of Philadelphia.*

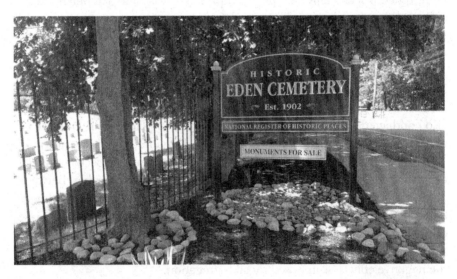

Eden Cemetery, Collingdale, Pennsylvania, is part of the National Underground Railroad Network to Freedom. William Fitzgerald's grave was relocated here after Lebanon closed. *Author's collection.*

last address was 1626 Bailey Street in South Philadelphia's Ward 7, which then had the city's largest black population.[179] William was buried in the black-owned Lebanon Cemetery, which had an area reserved for USCT veterans. Founded by and for blacks in 1849, the cemetery contained a chapel where abolitionist William Still hid his journals about the escapes and rescues of freedom seekers and aid he provided them; he later published these stories in his 1886 book, *Still's Underground Rail Road Records*. Sadly, like other black cemeteries, Lebanon was the target of grave-robbing rings that undertakers and doctors organized to secure corpses for medical college dissections.[180] In 1903, Lebanon's burials were reinterred at the newly opened Eden Cemetery for blacks outside Philadelphia in Collingdale, in a section called Lebanon. While most of Lebanon's reinterred burials do not have assigned grave locations, free-born William Fitzgerald rests among some of Philadelphia's most prominent black residents, including William Still. Eden is now part of the National Underground Railroad Network to Freedom.

If William had passed as white for part of his life, he went to his grave identifying as a black man. He told the attending physician how he wanted to be remembered: "Wm Fitzgerald. Black male. Born in Delaware. 1839."

ABRAHAM STOUT

"I Cannot Live on $12 a Month"

Abraham's neatly written April 25, 1910 letter to the U.S. Pension Office was purposeful and direct. He meant every word and expected definitive action: "I am disabled and cannot do a day's work. And my wife is getting old. I cannot live on $12 a month. If it was not for the help of my son I would not live at all."[181]

By law, the sixty-one-year-old's monthly payment should have been higher. He had heart and kidney disease, rheumatism and generally declining health. In 1865, while serving in the army, he was hospitalized for three months in Edinburg, Texas, for illnesses he claimed permanently impaired his health. Twelve dollars was a paltry amount for a man his age and condition. He outlined for the commissioner the context of his concerns about inequitable treatment: "There is soldiers to-day who is getting $24.00 a month that is not near as old as I am. And never had a day's sickness in his life. I am past the age of $15 a month and I am not getting that."[182]

Abraham's initial 1880 disability claim was rejected, as were subsequent applications. Eighteen years later, he was approved for six dollars per month for rheumatism and heart disease. In 1903, that amount was increased to eight dollars and to twelve dollars in 1907 for "rheumatism, disease of heart, and eyes, disease of kidneys and general disability."[183]

Born in 1849 to free parents Noah and Lydia Stout in Springfield, Delaware County, Pennsylvania, Abraham was fifteen years old when he enlisted on September 16, 1864—not eighteen years and eight months as his "X" signature professed. By then, he was ambitious and independent. In 1860, he had lived with and worked for James Rhoads, a Springfield-area farmer whose land and personal property combined was worth $42,000. Abraham's father, Noah, had remarried a younger woman, Annie; begun a new family, which included Abraham's brother William by their mother, Lydia, whose fate after 1850 is unknown; and worked as a coachman in nearby Media, Pennsylvania. Noah had personal property worth $100. Abraham was on his own. He also worked in Newtown, Bucks County, Pennsylvania, before enlisting in the army for one year and a $100 bounty.[184]

In the decades after enlisting, when he signed his name as X, Abraham's reading and writing abilities improved. He, his wife, Harriet, and son Elmer, who attended Harmony Grove School (later Lincoln School) in Lincoln Village for seven years, likely helped compose the 1910 letter. "I cannot live off of what I get," Abraham concluded, reasserting his hard-earned dignity, signing, "Yours respectfully From Mr. Stout."[185]

Around the time he wrote this letter, the proud 41st veteran whose unit helped bring an end to the rebellion and his son Elmer were witnessing a resurgence of racial discrimination that would affect how black and white children would be educated well into the twentieth century. Elmer attended Harmony Grove between 1894 and 1901, when black and white students were taught together in the same classrooms from the early 1870s. In 1909, Harmony Grove became a primarily white school when the school board decided to segregate black students and built what protesting residents called the "Jim Crow" school:

DON'T WANT JIM CROW SCHOOL

Protesting against what they call the new "Jim Crow School," the colored residents at Lincoln University yesterday refused to allow their children to attend unless they were put in the regular school building with the white children. About twenty of them came to the school yesterday, but on finding

that they were not to be allowed in the main building they returned to their homes. The entire village which is composed mostly of colored people is up in arms over the matter and all sorts of things are being threatened the School Board of Lower Oxford, who are responsible for the new arrangement.[186]

Claiming to ease overcrowding at the school where thirty-five of the sixty students attending were black, the board set up a separate, segregated school with a black teacher across the street "fitted up with good substantial furniture, single desks and all the conveniences."[187] But the students' parents, many of whom had seen slavery, endured the war to end it and still encountered discrimination, were not buying the separate but equal lie. Their children would not attend the "Jim Crow School." And they were not backing down:

As a result the new teacher of their own race sat alone in her room all day yesterday and the Directors, growing more angry every minute at what they consider the unreasonableness of the negroes, put their heads together and decided to fight until every negro child in Lincoln Village was attending the school which they had provided.[188]

At the time and prior to requesting more money, Abraham occasionally worked at the phosphate factory in Lincoln Village, where he had purchased a house. He and Harriet married on October 7, 1875. They had a daughter,

Former Harmony Grove School. Abraham Stout's son attended this school, when black and white students were educated together in the same classrooms, until 1909. *Author's collection.*

Cassana, who may not have lived to adulthood, and son, Elmer, who lived with his parents into late adulthood before marrying. The family moved around often, living in London Grove, New Garden and Lower Oxford, which includes Lincoln Village.[189]

Abraham seems to have been born with a migratory spirit. Or maybe his movements stemmed from the need to survive. After leaving the army, he returned to Springfield and Newtown to work for previous employers. From there he moved to Philadelphia in 1870, joining Noah, whose net worth had increased to $200. That year, Abraham worked as a driver, like his father, and lived with fellow veteran Abraham Hickson before moving to Chester County. Settling near Hinsonville, Abraham and his family joined Methodist Hosanna Church, another Stout tradition. His father, Noah, eventually returned to Springfield, his probable birthplace, where he died on August 21, 1886, and was buried at United African Methodist Cemetery in nearby Marple.[190]

Abraham worked as a teamster and farm laborer until his body gave out, trying for nearly two decades to get some help. The annotated summary of his pension claims shows an exhaustive and undoubtedly exhausting process of filing and refiling:

> *Filed original Claim January 6, 1880 alleging kidney disease and gravel contracted in January 1865. Rejected Dec. 16, 1893. No pensionable disability. Declaration filed July 12, 1890 under Act of June 27, 1890. Alleges kidney disease and rheumatism. Rejected Feb. 10, 1891. Declaration filed March 27, 1891 under Act of June 27, 1890. Alleges kidney disease result of chronic diarrhea, gravel, rheumatism, slight wound near groin, right side. Rejected December 16, 1895. Not ratably disabled under Act of June 27, 1890 by the disabilities alleged. See: disease of heart shown in ratable decree but it is not alleged and cannot be in the absence of history of rheumatism....Declaration filed July 16, 1897 alleges kidney disease, rheumatism and heart trouble. Declaration filed Dec. 8, 1897, under Act June 27, 1890 alleges rheumatism and heart trouble. Rejected May 10, 1898. No ratable disability. Declaration June 9, 1898. Under Act of June 27, 1890, alleges rheumatism disease of heart, disease of kidney and lungs. Admitted for rheumatism and disease of heart. No other disability affecting rate. Former rejections adhered to. Declaration filed April 7, 1899 rheumatism, disease of heart, lungs and kidneys. Declaration filed May 22, 1899 kidney disease and rheumatism. Rejected Nov. 7, 1900.*[191]

Effective May 23, 1912, Abraham began receiving sixteen dollars per month. He died less than two years later at home on December 13, 1913. Harriet received payments that had reached forty dollars per month when she died on May 29, 1929. Her death certificate reveals that she was seventy-eight, and her parents were Samuel Richardson and Cassie Rice. Her daughter Cassana, sometimes called Cassa, was named in memory of her grandmother Cassie. Both Abraham and Harriet are buried at Hosanna.

Elmer eventually married and worked as a track man for the Philadelphia Railroad. He died at the age of sixty-six on November 26, 1951. Breaking family tradition, Elmer did not join his parents at Hosanna. He was buried at Rolling Green Memorial Park in West Chester, Pennsylvania.[192]

Abraham Stout stood five feet, nine inches; had a dark complexion, eyes and hair; and weighed 155 pounds during his most healthy and productive years. Between census and pension records, the date of his birth fluctuates, sometimes 1837, 1838 or 1846. But 1849 seems most accurate and what his parents told the 1850 census taker, who recorded newborn Abraham's age as "0." Through his recorded life, from enlistment, relocation, marriage and settling in Hinsonville, and by his written statements, Abraham left an impression. Born free, he knew his origin and identified with a black community proud of its heritage and place in Chester County history. Knowing the importance of his military service to his country, he was determined to be properly compensated for it and remembered.

The missing Chester County record of his 1913 death and its cause seems almost inconsequential, since a veteran burial record provides details of Abraham's army service and shows where in "Hosanna A.U.M.P. Colored" Cemetery he is buried: West Section.[193] His fallen headstone rests on the ground facing heaven. Faintly visible letters require one to lean in to read them. One by one, each emerges from the corroded stone, becoming more vivid: ABRAHAM STOUT.

Remember me, orders the soldier buried here.

5

"We Came Here to Fight for Liberty"

W e came here to fight for liberty and right, and we intend to follow the old flag as long as there is a man left to hold it up to the breeze of heaven," said Nathan Flood, an orderly sergeant of the 25th's Company K, writing to the *Christian Recorder*. It was late January 1865, and his unit, which departed Camp William Penn with 90 men, had lost 25 to illness. The remaining 65 were living in tents in a bayou near Barrancas, Florida. Between spring and summer, the regiment would lose 150 men to scurvy, and as many who survived would be affected by the disease for the rest of their lives, Lewis Ringold among them.[194] Lewis enlisted on February 10, 1864, served with Nathan in Company K and died from bone scurvy within four years after returning home.

Despite these ominous circumstances, the men's faith and pride were strengthened every time they looked up at their regiment flag. Designed by Philadelphia artist and civil rights activist David Bustill Bowser, the 25th USCT flag depicted a black man whose shackles fall from his ankles as he steps forward to receive his musket from the Goddess of Liberty. Upon their return from the war, the 25th's victorious survivors paraded through Philadelphia to present their liberty flag to the Union League, which formed to sponsor black troop recruitment and training.

Hugh Hall and Lewis Palmer enlisted on January 5, 1864, and served in Companies A and K, respectively. Stationed at Barrancas, Company K was the smallest of the regiment. Assigned mainly to picket duty, some of the men helped destroy a Rebel-controlled sawmill, a raid that enabled them

The 25th USCT Flag is inscribed "Strike for God." *Library of Congress.*

to secure timber to build more comfortable barracks. Between picket duties and drilling, they held prayer meetings twice a week. Some used the time to learn to read. Their comrade Nathan used his time to write accounts of the regiment's experiences, including concerns about infrequent pay, for the *Christian Recorder.* "All that bothers us now is the non-appearance of the man that carries the greenbacks," he reported.[195] The paymaster had not been around for nine months, an unwelcomed, familiar occurrence. Jacob Johnson of the regiment's Company H told the *Christian Recorder* a few months earlier that while the men were willing to endure scurvy, hardships and combat with the enemy, "'tis hard to wait month after month, day after day" without receiving pay. His closing plea to the editor conveyed the painful predicament the men of the 25th and many USCTs faced:

> *Why are we not paid? Why are we promised and promised time and again, and yet receive no pay? Are we not worthy of it? The Scriptures say, "The laborer is worthy of his hire." They tell us we shall certainly get it. But when will that be? Will it occur when our families, driven to destitution and despair, shall wander from house to house begging their daily sustenance? Or, when driven from place, they shall seek the alms house for refuge? Justice echoes shame on such dilatoriness.*[196]

HUGH HALL

Buried in Barrancas National Cemetery

A wounded, sick Hugh Hall died at a regimental hospital near Barrancas five months after he enlisted. He was thirty-three years old, stood five and a half feet tall and had black hair and eyes and a yellow complexion. He enlisted for three years and had a family to support. Around 1855, he married Sarah Walls, Albert's sister, and they had three children: Rachel, William and Amy. They lived in Lower Oxford, Pennsylvania, with five Walls family members, including Albert, who was around Hugh's age. Born in Pennsylvania, Hugh earned a living as a brick maker and farmer. Few details about his early life and family are known, although he may have been related to Hugh Jackson, with whose family he had lived earlier in Oxford.[197]

According to Company A's muster roll, Hugh died from wounds and undisclosed illness on June 29, 1864. He had been paid $7.00 per month. At the time of his death, he owed the Union army $24.07 for clothing, and the army owed him a $300.00 bounty. Sarah likely received the $300.00 along with Hugh's personal effects: a hat, a forage cap, a uniform coat, a pair of cotton drawers, a pair of shoes and a rubber blanket. She filed for a widow's

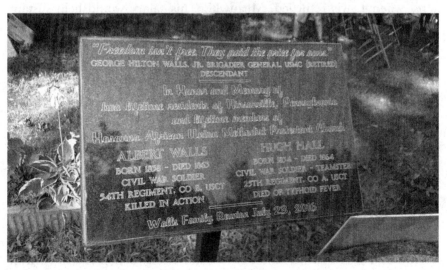

Hugh Hall–Albert Walls memorial marker placed in Hosanna Cemetery in 2016. *Author's collection.*

pension on December 15 and soon received $8.00 per month, plus $2.00 per month for each of their now four children: Rachel, William, Amy and John James.

Walls descendants have placed a memorial marker in the Hosanna Cemetery for Hugh and Albert, but Hugh was buried with members of the 25th in section 10 of the Barrancas National Cemetery in Pensacola. His burial plot is number 764.[198]

LEWIS WILLIAM RINGOLD

Man from Port Deposit

Lewis got married the day before he reported for duty at Camp William Penn. He and Augusta Russell made vows to each other on February 9, 1864, in Philadelphia, a first marriage for both. Reverend John B. Reeve presided over what was likely a small, semi-private ceremony followed by the young couple sharing a brief evening to seal their love before Lewis headed to camp. They were reasonably hopeful. They would resume their life together, have children and maybe purchase a house and a few acres when Lewis returned. Meanwhile, his salary would help sustain his bride.

This Tuesday afternoon and evening would be one of their most memorable, pleasant times as a couple. Within five years, the twenty-one-year-old Lewis would die destitute, leaving Augusta childless and facing an uncertain future.

Lewis was born in Port Deposit on the east bank of the Susquehanna River, Cecil County, Maryland, where in 1838 three railroads merged to form the Philadelphia-Wilmington-Baltimore Railroad Company. The railroad, quarries and fisheries provided black people, free and enslaved, income and some mobility. But more is known about Lewis's birthplace and social community than him. The few details about his life in Port Deposit, his family and how he reached Oxford, his adopted home, are speculative.

One of Port Deposit's oldest black churches is Bethel AME (African Methodist Episcopal), which was formed in 1818 as part of the Baltimore circuit mission when Bishop Richard Allen sent Reverend Jeremiah Miller to minister to slaves and growing numbers of free blacks there and in

nearby Havre de Grace, Harford County. In 1848, free blacks formally organized their church and met in a converted house in the former Cedar Street neighborhood where some black Ringolds lived. In 1911, the church relocated to Main Street, where today it opens its doors every Sunday for 11:15 a.m. worship. Built within one of the city's myriad hills, the remodeled building retains a historic appearance and presence; its outer walls are covered by shaped granite stones from the town's legendary quarries. An elevated cornerstone visible from the street pronounces Bethel's place in and witness to Port Deposit's history.[199]

Every building on Main Street either faces or backs onto the Susquehanna. From Bethel's hillside perch, the view of the river's graceful flow belies the hardship its black residents have endured over the centuries. "There's a lot of pain here that people don't want to talk about," said Reverend Brenda D. White, Bethel's pastor, alluding to documented racial violence against the church and its members. A pictorial church family tree in the foyer shows founding families and families connected to Bethel over nearly 170 years, including the Ringolds, whose names appear in the lower right area of the tree's roots. Thomas Ringold and his wife, Mary, were founding members. A property owner and merchant, and described as mulatto, Thomas headed the only free black Ringold family listed in the census reports between 1850 and 1880. His origin and relationship to Lewis are unrecorded.

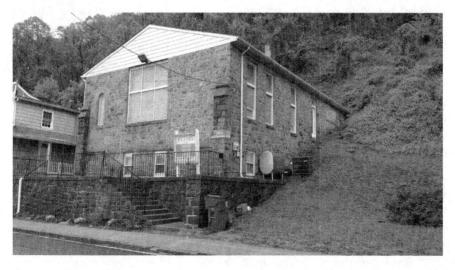

Bethel AME Church, Port Deposit, Maryland. Ringolds were among Bethel's 1848 organizers. *Author's collection.*

Between 1850 and 1851, Lewis and some of his relatives, either fleeing slavery or seeking opportunities as manumitted people, used the railroad or horse-drawn wagons to distance themselves from Port Deposit, traveling to Oxford, where they settled. Lewis found work as a farmer and wagoner for businessman Ebenezer Dickey, a relative of Ashmun Institute founder John Miller Dickey. He appeared in the 1860 census living with Stephen Ringold and Caroline Ringold in Lower Oxford, all three listed as Maryland-born "free inhabitants," suggesting a familial relationship. Though not listed in the census, a William T. Ringgold, likely Lewis's father, and whose middle name was probably Thomas, is buried next to Lewis in Hosanna Cemetery.

At the time of enlistment, Lewis stood five feet, six inches and had dark skin and matching hair and eyes. Unable to read or write, he signed his enlistment papers with an X, probably noticing that his surname was sometimes spelled with two Gs. Examining army physicians pronounced him healthy and suitable to serve three years. By all accounts a healthy man before enlisting, Lewis's hospitalization at Camp William Penn from March 12 through April foreshadowed recurring illness. He was hospitalized at least three times during his sixteen months of service. After departing camp for the warfront, Lewis was readmitted to a regimental hospital on July 14 for an unspecified illness and could not return to duty until September. By October, Lewis was diagnosed with the disease that disabled him and would claim his life. "I was first afflicted in the knees, legs and left arm with general weakness while waiting on those that had scurvy," including Hugh Hall, he later recalled in his disability claim.[200] He contracted scurvy while tending his comrades who were patients in a regimental hospital in Barrancas. The following year, he was absent from duty again in May and June. Comrade Lewis Palmer later recalled his friend being "reduced and much disabled" throughout most of 1865. "I visited him several times," Palmer said. "He was very poorly, hardly able to get along, had almost lost the use of his arm."[201]

Lewis was discharged from service on June 16 from the U.S. General Hospital in Barrancas, having been last paid through February. He owed the army $5.50 for clothing. The army owed him back pay and a $300 bounty.[202]

Great Four Days Meeting in Dantz's Woods, near Ashm[u]n College, half a mile from Buttonwood Station, on Baltimore & Phila. Central Railroad. The Trustees and members of Hosanna A.M.E. Church will hold a four days' meeting in the above named woods, beginning August 30th. During

that time the Masons and Samaritans will parade, and have sermons delivered to them, and the sabbath School will hold its harvest home. The Trustees will prepare meals in the woods. Come over and help us. John W. Stevenson, Minister.[203]

Dantz's Woods was Hosanna's favored site for camp meetings and a gathering place for community picnics and ceremonies. A part of Edward Walls's 1841 land purchase from Joseph Dance to establish a burial place for Hosanna members, Dantz's (or Dance's) Woods' August meeting probably lured Lewis, who in late June returned home, hoping in vain to resume a normal life with Augusta.

Family doctor D.W. Hutchinson examined Lewis, noting his declining health due to "scrofulous disease of the arms," which "necessitated the amputation of the right arm."[204] Lewis filed a disability claim on February 16, 1867, which was approved based on a finding of periostosis resulting from scurvy that affected his remaining left arm and leg, neither of which he could use much. The monthly eight-dollar payment was not enough to sustain him, however, so he used his "back pay and bounty to keep a small shop...but was unable to attend to it" because of his failing health.[205]

Lewis "has but little use of the left arm and left leg," Hutchinson reported the following February, saying, "His limbs are still discharging and at times very offensive."[206] By the following May, Lewis was living in the Chester County Poorhouse. He died there on July 26, 1869, at the age of twenty-six. Augusta's whereabouts or living circumstances at the time are unknown, but she filed a widow's claim in 1872, which was paid. She lived in neighboring Delaware County, Pennsylvania, for a few years before disappearing from public records.[207]

Caroline Ringold, Lewis's presumed sister, had her share of hardship. In 1870, perhaps now lacking some support from her older brother, the twenty-year-old single mother lived in the Chester County Poorhouse with her three children, including a young daughter and son and five-month-old infant. The record stated that the following year, Caroline left the poorhouse and "went to her home near Oxford with her two children," implying the loss of the infant.[208]

Lewis rests on the east side of Hosanna facing the direction of the road leading to his place of birth. His headstone incorrectly reads *L.W. Ringgold*, recalling the middle name "William" he often used and his relationship to William T. Ringgold (January 28, 1801–August 9, 1861), buried next to him, for whom no public record has been found. A GAR medallion and U.S. flag decorate Lewis's grave site.

Lewis Ringold grave site at Hosanna Cemetery. Lewis was the first of Hinsonville's surviving Civil War veterans to die from a service-related disease. *Author's collection.*

LEWIS PALMER

"A Worthy Man of Good Habits"

Lewis Palmer knew he would never regain his health, as his doctor, James Eves, submitted a 1902 affidavit supporting a request for more pension money. He was in bad shape, unable to work and deserved more help. He had heart disease and chronic muscle and joint pain, especially in his lower back. Lewis "is incapacitated from earning a living and has been for a long period and...he is a worthy man of good habits," said Eves, who had been treating him for thirty-two years.[209]

"A worthy man of good habits," Lewis hadn't been a healthy man since he was discharged from the army in 1865. Though disabled, Lewis was a farmer determined to support himself; his wife, Hannah, whom he married in 1868; his children; and relatives living within his household. He did not file a pension claim until May 20, 1880. He was thirty-eight years old then, and his fourteen-year-old son, Lewis, worked as a laborer on a Lower Oxford farm. Injured at Fort Barrancas on August 15, 1864, Lewis had attorney Theodore Stubbs submit the following statement:

Was injured, strained and over worked lifting heavy cannons at landing, and while propping, prying and lifting to get them mounted on the fort felt hurt and lame, sore and miserable for something like three weeks sick, nervous and dizzy and fainty at times. And then went into Hospital with sore right lung, breast and side and strained kidneys at Post Hospital Fort Barrancas from about September 7, 1864 to March 1865. Was still sick in summer of 1865 but able to act as nurse then 'till discharged. Lewis X Palmer[210]

Stubbs submitted additional evidence on July 25, 1881, to support Lewis's disability claim, including a statement by George H. Bond, forty-one, a resident of Chatham, Pennsylvania, who served in Company K and saw Lewis injured. George signed his statement that Lewis was disabled on August 12, 1864:

...by lifting and mounting heavy guns and trucks on the wharf near the Navy Yard, and heavy truck falling upon him, whereby claimant was injured in kidneys and right lung. He was sent to post hospital for about a month, returned to duty, but was sent back. Assisted in removing the truck from Lewis after it had fallen on him. George H. Bond[211]

A leader of the colored George F. Smith GAR post in Chester County, Solomon Butcher, a forty-five-year-old resident of Avondale, said he, too, was with Lewis on detail that day, moving and mounting the cannon, and witnessed his comrade's injury. Emory Wilson of Oxford, Lewis's friend of thirty years, says the five-foot, ten-inch man was strong and healthy before enlisting but was, since his discharge, sickly and barely able to work:

He can work part of the time but his lung, back and side troubles him fearfully and he says he feels miserable and don't know what is to become of him. He certainly looks bad enough and about played out for working at manual labor which is the only way he tries to make a living. Emory Wilson[212]

Examining physicians determined that Lewis was entitled to a one-half disabled rating, and he was granted a two-dollar monthly pension. Lewis filed claims for increases in 1882, 1883, 1887, 1889 and 1897. By 1897, he was receiving six dollars. On April 24, he explained his desperation to a West Chester physician, hoping an increase was forthcoming:

I am a laborer and am able to work half of my time and then I am not able to do hard manual labor. I have not earned more than three dollars. Injury to my side and back which received while in the service is the principal cause of my disability.[213]

The physician described the fifty-seven-year-old Lewis as a "tall rather stout looking colored man" with a good "muscular system," solid nutrition and healthy skin. The physician had Lewis walk three blocks to test his heart rate and respiration and then concluded he had "no objective evidence of injury."[214]

Lewis, whose hands were noticeably hardened from labor, filed again in 1901 and 1902 for increases, undergoing more exams of his weakened body. A year after Dr. James Eves's 1902 adamantly worded affidavit, Lewis, whose ailments now included kidney disease, received an increase to $8 per month. He and Hannah had a mortgage on their Lower Oxford house, which they shared with their three daughters, Sadie, Maggie and Hannah, and granddaughter Eva. His monthly pension remained at $8 until December 5, 1912, when he received an increase to $21.50 per month due to new pension laws. Three years later, he died from kidney failure. Heart valve disease and asthma were contributing factors. He was seventy-three years, nine months and twenty-five days old.

The "worthy man of good habits" was born on April 9, 1841, in Nottingham, Pennsylvania, possibly free. He lived with his mother, Caroline

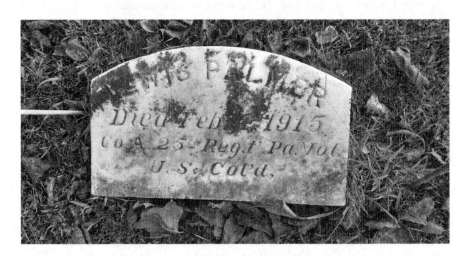

Lewis Palmer grave site at Hosanna Cemetery. *Author's collection.*

Hann, and siblings there in 1860. His Maryland-born mother worked as a washerwoman and had personal property worth seventy-five dollars. Lewis's father, Jacob Palmer, was listed on his son's death certificate but appears in no other record.

Lewis married Hannah Roades on August 28, 1868. Hannah filed for a pension following Lewis's death, which was paid, and lived in Lower Oxford until her death in 1923. She was eighty-two years, three months and eight days old.

Hannah rests somewhere in Hosanna Cemetery near Lewis, who died on February 14, 1915—fifty-one years after he joined the USCT, on January 5, 1864.[215]

6

Mystery Men of Maryland

George W. Duffy and Stephen J. Ringgold were born in Maryland's Harford and Cecil Counties, respectively. Details of their early lives, the fates of their enslaved parents or how and why they settled in Oxford, Pennsylvania, remain a mystery. Yet a once worn route people fleeing hardship or slavery in Harford and Cecil Counties used to get to Hinsonville is known. More than a century ago, five bridges were built to carry a dirt road across the swamps of Elk Creek running near Hinsonville. According to Lincoln University historian Horace Mann Bond, one of those bridges once was "a landmark to escaping fugitives who had crossed the Susquehanna at Havre de Grace or at Conowingo," both spanning Cecil and Harford Counties, "and made their way northward along the Elk to turn to the left to find temporary refuge at one of the Negro houses at Hinsonville" or nearby Quaker homes.[216]

However George and Stephen arrived in the Hinsonville-Oxford area, they became friends before enlisting in the 22nd during the second week of January 1864—George in Company B, Stephen in Company H—and looked out for each other the rest of their lives. Born enslaved and used to struggling to survive, George and Stephen seemed destined to join the unit of soldiers whose courage and determination defined them.

The 22nd Regiment flag depicted a black soldier killing a white Confederate soldier, foretelling the unit's success in defeating Rebel forces and freeing slaves after fierce fighting during high-casualty battles at Chaffin's Farm and Dutch Gap in Virginia. The only black regiment to lead President Abraham

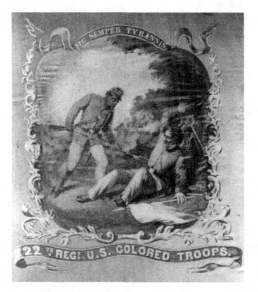

The 22nd USCT Flag is inscribed *Sic Semper Tyrannis*, "Thus Always to Tyrants." *Library of Congress.*

Lincoln's funeral procession in Washington, D.C., 22nd soldiers are noted in history for their discipline and loyalty. George and Stephen were among them that solemn, memorable day, as the *Christian Recorder* reported:

> *First in the order of procession was a detachment of colored troops, then followed white regiments of infantry and bodies of artillery and cavalry; navy and marine and army officers on foot; the pall bearers, in carriages; next the hearse, drawn by six white horses, the coffin prominent to every beholder, the floor on which it rested was strewn with evergreens, and the coffin covered with white flowers; the diplomatic corps, members of Congress, Governors of States, delegations of various States, fire companies, civil associations, clerks of the various departments and others, all in the order of the procession, together with public and private carriages. All closing up with a large number of colored men.* [217]

GEORGE W. DUFFY

He Was Born on the Scotland Farm in the State of Maryland

On April 22, 1905, George hired a notary public to certify his response to the U.S. Pension Office request that he provide proof of his family church or the location of the Harford County plantation where he was born. In

his late sixties, George was crippled in his left leg, blind in his right eye and enduring constant pain in his left eye and head, all of which had been reported to examining physicians since 1877, when he began receiving a four-dollar monthly pension for the leg injury he incurred while in the army. A gunshot shell struck George's left ankle, cutting the heel cord, while he was on "fatigue duty digging in Dutch Gap Canal" in Virginia, in August 1864, he said.[218] The 1st USCT chaplain, H.M. Turner, who visited Dutch Gap during that time, described how the canal was being cut to allow gunboats to pass through. He watched the entirely black working crew "constantly harassed by the explosion of rebel shells in their midst, which sometimes occasions fearful destruction among them."[219] The regiment's orderly, Charles A. Haitsock, also described to the *Christian Recorder* the dangerous and often deadly conditions under which George and other men worked at Dutch Gap:

> *Our boys have a very dangerous work to do...there that a large detail out of our regiment has to work seven hours every day. The enemy have batteries planted all around there, and have a good range on the canal. There is not a day that passes, but what a number of men get killed and wounded. It is a sorrowful sight to see the poor fellows stricken down in the twinkling of an eye when they are busily at work, not thinking of any danger, and in an instant a shell bursts, and he is either killed or wounded before he can escape.*[220]

George's physicians, commanding officer and unit mate Stephen Ringgold, who witnessed the injury, provided statements that helped him eventually secure a partial disability. "The ankle and about the heel becomes much swollen and painful at times and disables me for work half the time and I claim pension on wound," George said in his 1877 application.[221]

Since that time, some of George's requests for pension increases had been approved, some denied. He received an increase to six dollars in 1881 and to eight dollars in 1890 after a surgeon noted his increasing lameness. Between 1898, when his request for an increase was denied, and 1904, when he reported "total blindness in right eye and pains in the head and left eye," George's monthly pension had reached ten dollars.[222]

The honorably discharged veteran, now fully disabled and unable to work, direly needed money to support himself and his family—help that might hinge on proving where his family worshipped and lived while enslaved. Whether free or self-liberated, George was likely born to enslaved parents

between 1834 and 1837 in Harford County, parents from whom he had been separated by the time he enlisted in 1864, identifying himself as a farmer born in Harford County. The notary summarized George's story, saying, "He was always told that the 10th day of October as his birth day because his mother had told him that he was born on that date on the Scotland farm."[223] George's death certificate later listed Alex Duffy as his father. But the name of his mother, the woman who enshrined in her son's memory the day and month he entered the world, is unknown. Neither of George's parents appear in any records documenting his life. Exhausted from his leg pain, years of hard labor and encroaching illnesses and struggling to get higher payments, George instructed the notary to tell the Pension Office what should be obvious: he "cannot furnish a certified copy of family church or plantation" and "has no way of getting one."[224]

June 1863 was the first time George W. Duffy was identified in the public record; he registered for the draft and described himself as a single, twenty-two-year-old farmer working in Lower Oxford. He enlisted on January 9, 1864.[225] Upon his discharge on October 16, 1865, in Beaumont, Texas, George collected his one-hundred-dollar bounty and returned to Hinsonville. He and Jane, the daughter of longtime residents Stephen and Elizabeth Ann Butcher, were married on September 15, 1866. Between 1868 and 1890, they had six children: Theodore, William, Amy, Mary, Edmond and Pearl, all of whom enrolled in public school. George's requests for pension increases closely aligned with the births of his children.[226]

George could neither read nor write and mostly worked as a farmer, day laborer and "engineer" in the Oxford area. By 1900, George, Jane, Pearl and a toddler granddaughter named Dolly Wright were living in Chester, in neighboring Delaware County. George earned wages as a day laborer, as did Jane, who had been unemployed for half the year.[227]

In August 1906, an examining physician reported George's multiple ailments to the Pension Office to support his request for more money:

I find him to be totally blind in right eye due to cataract. There is also a beginning cataract in left which have almost disrupted his eye sight. He complains of rheumatism in both legs. There is a severe bronchial…which causes almost constant coughing. These conditions totally disable him from manual labor.[228]

That September, George's monthly payment increased to twelve dollars for his leg wound, impaired vision, heart disease, bronchitis and rheumatism.

George Duffy grave site at Hosanna Cemetery. *Author's collection.*

"I am unable to do any labor," said the nearly seventy-year-old, who died the following September from "attack of apoplexy" (unconsciousness or incapacity resulting from a cerebral hemorrhage or stroke). Within one month, Jane began receiving a widow's monthly pension of eight dollars. George left no "real or personal property, except for his household furniture valued at thirty dollars," according to the 1907 tax assessor.[229]

George is buried on the west side of Hosanna Cemetery at the rear of the church. Born on a forgotten tract of Harford County land, he was laid to rest in a place he called home and by a community that remembers him. Jane died suddenly two years later, also from apoplexy, and is buried somewhere in the cemetery with George and her parents. The Pension Office eventually reimbursed daughter Amy $35.20 for Jane's burial expenses.

George's headstone is decorated with a GAR medallion and U.S. flag, his service to the Union noted by many who never met him.

STEPHEN J. RINGGOLD

"I Was Born at Port Deposit, Cecil County, Maryland"

The Havre de Grace Times *states that the ice in the Susquehanna river is at least ten inches thick, and sleighs have been crossing the river, and passing up and down it between Havre de Grace and Port Deposit on the ice during the present week.* Vincennes Gazette, *January 14, 1860*[230]

Stephen J. Ringgold was born in Port Deposit on August 11, 1836, according to preacher Jacob Jay, who recorded it in a family Bible. Stephen's parents were Isaac Ringgold and Sarah Jay. Sarah was likely related to Jacob and Jay families from Harford County across the Susquehanna River. Free and

enslaved residents of the neighboring counties could have sleighed across a frozen Susquehanna almost as easily as they ferried the river during warmer months. The Jay, Walls and Cole families migrated from the Havre de Grace area of Harford County to Chester County, Pennsylvania, and intermarried to form the nucleus of the Hinsonville community in the early 1840s. Members of the Ringgold families from Port Deposit accompanied or soon followed them.

Stephen was seven or eight years old when his owner sold him to John Moore, a Port Deposit farmer whose property in 1850 was valued at $4,000. Along with the fifty-two-year-old Moore, his wife and five family members lived eleven-year-old Stephen and ten-year-old Susan, both black and listed as Ringgolds—likely the surname of their former owner. By 1853, Stephen had settled in Oxford as a free man and joined the newly organized Mount Calvary AME Church, whose founding quote, Joshua 24:27, reminds members of the enduring strength of faith: "Behold, this stone shall be a witness unto us; for it hath heard all the words of the LORD which he spoke unto us; it shall be therefore a witness unto you." He worked for several businessmen, including Ebenezer Dickey, who hired him as a wagoner. A large, influential family, the Dickeys of Oxford owned large amounts of land, operated major businesses and were involved in the religious and social life of the community.[231]

In 1860, twenty-year-old Stephen was living with seventeen-year-old William (Lewis) and twelve-year-old Caroline, who both share his last name. He married Mary Hann from nearby Nottingham, but their union was brief, as she died in 1862. Stephen remarried on May 13, 1869, to Anna Johnson. They had seven children, born between 1871 and 1890: Mary Etta, Thomas Weldin, Nellie, John, Stephen, Sherman and Minnie.[232]

During the late summer of 1907, Stephen, his neighbors, friends and attorney Theodore Stubbs were busy preparing affidavits to the Bureau of Pensions to support his February 27 claim for an increased monthly payment. Congress approved a new pension act in February allowing increases for Civil War veterans. For Stephen, this meant he was eligible to get fifteen dollars per month if he could prove he was the required age: seventy. "Dear Sir," the bureau letter informed him, "you are advised that the best obtainable evidence of the date of your birth is required by this Bureau."[233] The options listed for the now elderly black veteran, who was born into slavery and separated from his enslaved parents while a youngster, were a verified public record of his birth, a verified baptismal record, a verified family record of his birth or a magistrate-certified Bible record of his birth.

The letter concluded, "If you are unable to furnish any of the evidence indicated, you should state that fact, and the reasons why you are unable to furnish it, under oath."[234] Like formerly enslaved veteran George Duffy, Stephen was expected to verify his slave origin. Although Stephen's 1864 enlistment record listed him as a free man, he had to provide the name and physical description of his former owner. It took another four years for the bureau to accept April 11, 1836, as his birthdate and increase his pension from fourteen to fifteen dollars per month in 1911.

It had been a long haul for the former slave and wagoner who made his way to Chester County, eventually enlisting in the army. During his seventeen months of service, he was diagnosed with heart disease and qualified for an immediate six-dollar pension upon discharge. His poor health persisted, disabling him from working full time, he told the bureau in 1879, seeking an increase. "I have been subject to spells of choking and palpitation of the heart and my whole side [left] disabled," he said. "Have had to be hauled home several times while up town when I took a spell."[235]

Although Stephen was pensioned in 1865 for disease, the bureau required more evidence to support his claim that the illnesses originated during army service. Stephen asked his Hinsonville comrades George Duffy, Wesley Jay and Lewis Palmer to attest to the condition of his health when their three regiments were on duty in Yorktown, Virginia, on April 15, 1864. The men signed statements describing how Stephen fell ill from heavy marching, exposure and blood loss. His unit mate George Duffy said Stephen "contracted shortness of breath and hemorrhage and came near dying in the hospital," and "soon afterward he was brought back to regiment at Petersburg and on account of sickness was taken away again."[236] After Stephen was discharged and returned to Philadelphia, he was re-hospitalized, "very weak and bleeding, barely able to walk," George said.

While army medical records verified Stephen's illnesses, he still had to convince the bureau that these were not preexisting conditions. His longtime friend from Oxford, Ellis Watson, tried to help. His signed statement asserts that Stephen was physically sound and healthy before enlisting:

> I was present in the room in recruiting office on Chestnut Street, Philadelphia on or about January 10th or 15th 1864 and saw Ringgold stripped stark naked and examined carefully by the army surgeon. The doctor said "there is nothing wrong with this man. He would stand chain lightening. He'll pass." I know said claimant was free from hemorrhage and shortness of breath and perfectly sound and healthy.[237]

Former employer William McCullough of Lower Oxford knew Stephen before 1864 and noted how after his return from the army he "was not able to work, but was sometimes able to potter around and do light jobs."[238] When Stephen's benefit was increased to twelve dollars in 1881, he had chronic heart problems and hired contractors to help him do occasional well digging jobs. Filing again in 1884, Stephen was suffering from stomach disease. He said that he was "unable to lay on left side; unable to wear suspender on left side or anything pressing on it at all...[and] disabled by stomach trouble continually and my heart spells are so very bad I can't stand many of them."[239] Dr. Samuel Rea explained that his patient was "a frequent sufferer from indigestion and palpitation" and "unable to follow his occupation, that of excavator of cellars, wells, nearly or quite half of the time."[240] Following years of more testimonies from doctors, employers, neighbors and army mates, the bureau decided he deserved an increase to fourteen dollars.

Stephen and Anna owned their house at 17 Eight Street in Oxford, where six of their children still resided in 1900. Two of their sons, Thomas Weldin and John, would predecease them. A single, twenty-nine-year-old laborer, Thomas died in early January 1903 after falling from a train in Newark, Delaware. Known as "Chippie" in his Newark neighborhood, he was found unconscious by the tracks of the Baltimore and Ohio Railroad, the side of his head crushed and a gash extending from his forehead to his neck. Stephen was notified and hired an undertaker to return his son's body to Oxford for burial. The coroner ruled Chippie's death an accident. In April 1909, twenty-six-year-old John succumbed to tuberculosis after suffering for fifteen days.[241]

One of Stephen's legs was amputated in 1911, and disease soon claimed the other. Neighbor J.A. Watt pleaded on his behalf for more money under the act of May 11, 1912. The elderly veteran who once stood five feet, nine inches, he said, "is unfit to do anything at all, just sits on chair and has to be waited on."[242] Stephen began receiving $21.50 in late May. He died on February 10, 1913, at the age of seventy-six years, five months and nine days.

Anna began receiving $12 per month after her husband died. The matriarch reached the age of ninety-eight, passing on October 27, 1943. Although her resting place in the partially restored Mount Calvary Cemetery is no longer visible, her daughter Minnie lovingly buried her there at significant cost: $265. Minnie later requested reimbursement from the Pension Bureau. She received $36.

Another son, Stephen Louis, named for his father and perhaps an uncle, lived in his parents' house with his son and worked for the Pennsylvania

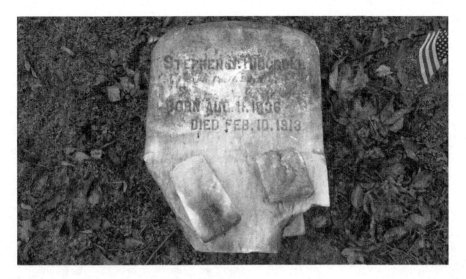

Stephen Ringgold grave site at Mount Calvary Cemetery. *Author's collection.*

Railroad Company. Though married, he and his wife were estranged. He was arrested one day while on the job and charged and convicted of assault and battery with intent to kill. Stephen was sentenced to a minimum of one year, nine months, and carried to Eastern State Penitentiary in Philadelphia on October 8, 1914, his twenty-seventh birthday. Like his father, he overcame hardships. Paroled on July 8, 1916, he enlisted in the army and served as a private first class in the 368th Regiment, Company G, during World War I. He returned to his family's Eighth Street house, where he resided until his death in 1953. Caring descendants placed the modern headstone that marks his well-attended grave at Mount Calvary.[243]

Mount Calvary Cemetery occupies a triangular lot at the intersection of Bethel and Calvary Roads outside of Oxford's western border, the original site of the church Stephen Ringgold joined upon arriving from Port Deposit. There he rests with members of his family and some descendants. While his early life experiences are lost to history, Stephen's elegantly aged marble headstone shows his army regiment and company and the dates on which he entered and departed this world. A U.S. flag and GAR medallion flank the monument now toppled over its matching foundation, honorably recalling the fallen, but clearly unforgotten man resting here.

7

"Considerable Applause" for Harriet Tubman

CHARLES WILLIAM COLE

Charles stood five feet, six and a half inches, and had a mulatto complexion and black hair and eyes. It was three days before Christmas when he stepped from the segregated train car and began walking the approximate mile toward Camp William Penn and his new identity: a soldier of the United States Colored Troops.

Earlier that morning, the eighteen-year-old farm worker boarded a Philadelphia-bound train in West Chester, where he enlisted for three years of army service, signing his commitment with an X. He was handed two travel requisitions to cover his fare:

> *Requisition to the West Chester and Philadelphia Railroad Company for transportation from West Chester, PA to Philadelphia, PA for one recruit "colored."*

> *Requisition to the North Pennsylvania Railroad Company for transportation from Philadelphia, PA to City Line, PA for one recruit enlisted, colored, Wm Cole, colored, 24ᵗʰ USCT.*[244]

The last of Hinsonville's men to enlist, Charles's 24ᵗʰ was the last unit to leave Camp William Penn. Soon to join his comrades on the battlefront, he

was beginning to notice shifts in the social order. Underground Railroad leader and businessman William Still operated a supply store at the camp and soon thereafter prevailed in a lawsuit against the railroad company that eventually discontinued the segregated passenger cars that he and thousands of determined black men endured to serve their country.[245] Arriving in the city, Charles boarded the segregated section of the North Pennsylvania Rail Road (now SEPTA regional rail) train and rode to the city's outskirts to the City Line Station near Broad Street and Cheltenham Avenues (now the Melrose Park station).

He walked until he saw the front gates of the camp, located on thirteen acres of farmland owned by Edward M. Davis, the son-in-law of abolitionist Lucretia Mott, who lived nearby and often greeted the soldiers. Intriguing shifts visible to Charles would reshape the future world in which his descendants would live. More than 150 years after he walked through the camp gates, the surrounding neighborhood was named La Mott to honor Lucretia Mott and the thousands of black soldiers who trained on those grounds. Custom-designed street posts bearing their likeness daily remind people that USCTs, including Charles, were there.

During his four months at camp, Charles was immersed in combat training and social enrichment. Reading, writing, arithmetic and Bible study classes were offered. Regular worship services included stimulating sermons, and periodically, well-known speakers visited. On Saturday, April, 1, 1865, he and his comrades listened intently as freedom fighter Harriet Tubman told stories of rescuing slaves and supporting the Union cause. "It was the first time we had the pleasure of hearing her," reported A.B., a 24th Regiment

Camp William Penn. *Gettysburg National Military Park.*

La Mott street sign memorializing USCT soldiers who trained at nearby Camp William Penn. *Author's collection.*

soldier, to the *Christian Recorder*, which regularly published USCTs' accounts of their training and battlefield experiences. "She gave a thrilling account of her trials in the South, during the past three years, among the contrabands and colored soldiers, and how she had administered to thousands of them, and cared for their numerous necessities," he said.[246] Charles might have beamed proudly, telling comrades how his neighbors helped people fleeing slavery who passed through Hinsonville, an area where Tubman sometimes operated. Unlikely to have called himself an abolitionist up to this point, Charles began to see his expanding role in the fight for freedom. She "elicited considerable applause from the soldiers of the 24th regiment, USCT, now at the camp," A.B. noted.[247] It was yet another reminder to the young Chester County farmer who signed his name as X of his role in shaping the future of his country.

"Vociferous shouts and hurrahs" arose two days later from the 24th's men upon hearing that the Confederate-held Richmond had fallen and that their fellow Camp William Penn–trained soldiers were among the first to enter the city, A.B. told the *Christian Recorder*. That celebratory mood subsided, however, on April 14, when President Abraham Lincoln was assassinated.

The next day, members of the city's black community and the 24th held a procession to honor the slain president. Beginning on Broad Street and moving down Chestnut to the State House, the march concluded at the steps. There the 24th's regimental flag was presented by G.C. White and

Octavius Catto, the black civil rights activist who was murdered in 1871 by a white political operative intent on discouraging blacks from voting. Artist David Bustill Bowser designed the flag depicting a USCT soldier "springing forward to receive a scroll, descending from the clouds, bearing the motto 'Fiat Justitia' [let justice be done], a reinforcement of the prophetic expectation 'Let Soldiers in war be Citizens in Peace'" inscribed over the painting. Concluding its coverage of the 24th's ceremony, the *North American* observed, "Everybody who saw them must admit that the bearing of these sable soldiers was in all respects martial and soldierly."[248]

Charles and his comrades were ordered to march in Philadelphia's funeral service for Lincoln, another history-making event in which the Hinsonville farmhand-turned-soldier participated:

> *In compliance with Special Orders No. 93 from Department Head Quarters, the 24th USCT will participate in the funeral obsequies of the late President of the United States—Abraham Lincoln in Philadelphia tomorrow. The line will form at 10:15 A.M.*[249]

Newspapers in Philadelphia and across the country noted their prominent presence.

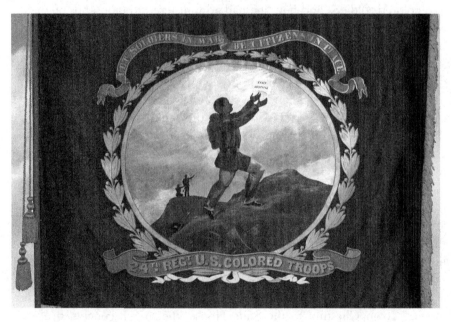

24th USCT flag replica. *Camp William Penn Museum.*

Abraham Lincoln mourning ribbon. Charles Cole's 24th Regiment marched in Philadelphia's funeral service for President Lincoln. *Library of Congress.*

Soon, Charles and the rest of the 24th departed for the warfront, encouraged by a minister's stirring sermon that Lincoln's death reinforced their God-ordained calling: "You must endeavor to do your duty! God, for some wise purpose, has allowed him to be slain! But, the day is not far distant when there will be a Moses raised up to conduct you through the sea of sorrow which now surrounds you."[250]

Charles's unit guarded Rebel prisoners at Point Lookout, Maryland, and maintained order in areas of Virginia where government supplies were distributed to needy civilians and Union troops. The unit was then ordered to Richmond, where it mustered out on October 1. After settling his account for clothing or cash advanced, Charles headed home to Pennsylvania with his $300 bounty.

He appeared in the 1870 census working as a farm laborer in East Marlborough, Pennsylvania, about twenty miles from Oxford. He married in 1873, although no record of the marriage or detailed information about his wife have been found. He filed for a pension as William Cole on May 17, 1880, and was paid, but NARA (National Archives and Records Administration) has not located his full file, making it difficult to determine the state of Charles's health or know more details about his personal life in the decades following army service.

Throughout his life, he was variably called Charles, Charles W., Charles William, C.W. or William. He appeared in the 1900 census as a married day laborer living alone in Northeast, Cecil County, Maryland, and, interestingly, in 1903 as a supporting witness for Josiah Cole's widow, Harriet, who filed a pension claim. Identifying himself as William Cole, age fifty-five, he said he had known Josiah "from his young manhood until his death" and his (Josiah's) previous, deceased wife, Ella. This suggested Charles's kinship or otherwise close relationship with the other Hinsonville Coles who, like him, were described as mulatto.[251]

Glimpses of his early life indicate that three-year-old Charles W. lived with his parents, Charles and Ellen Cole, and brothers, Josiah and

Marshall, in London Grove, Pennsylvania. Except for his father, who was listed as black, everyone else in the household was mulatto. By 1860, the widowed Ellen was living with her younger children and her parents, Josiah and Hannah Davis, in the Hinsonville section of Upper Oxford. Charles worked for and lived with James Casper (or Cooper), a mulatto blacksmith in Lower Oxford to whom he may have been apprenticed.[252]

Like men of his day, Charles moved often to find work. But he was around and well acquainted with Hinsonville families, including the Lees. On Sunday, June 5, 1905, he and Bertha Lee were married at Lincoln University, likely in the recently built Mary Dod Brown Chapel. Reverend George Carr, a professor of homiletics and English, officiated the ceremony. It was the second marriage for the presumably widowed Charles, then fifty-eight, and the first for thirty-one-year-old Bertha. Their son Fred was born between 1900 and 1901. The family lived in rented homes in Lower and Upper Oxford, where Charles earned a living as a laborer, as did Fred.[253]

In 1915, Charles and other neighbors helped Lewis Palmer's widow, Hannah, with her pension claim. Although she produced the required marriage certificate to the Bureau of Pensions, Charles had to attest to the Palmers' marriage. Like his friend Lewis Palmer, Charles adopted Hosanna as his home church and, like Lewis and other USCT veterans, chose to be buried there.

Between 1886 and 1889, a battle that at times seemed as fierce as some Charles had witnessed as a soldier waged between two factions of the church. After the congregation had raised funds to rebuild the older structure, disagreements over its new design ensued. The building committee split into two factions. Seeking an opportunity to expand its Baltimore Pike boundaries, Lincoln University president Isaac Rendall offered to buy the Hosanna property (including cemetery) for $500, a generous amount that would have covered the costs of a new church building as well as a lot on which to build it, which Rendall also offered to provide. One faction approved of the deal with Lincoln. The other faction, consisting of Walls descendants and relatives, was steadfast against selling the church or the cemetery, which Edward Walls in 1851 had deeded to the trustees of First Colored Methodist Protestant Church, later called Hosanna AUMP. Built in 1843, the church had an even longer history as the African Meeting House, which Walls pioneers organized. The half-acre lot, both ancestral and sacred ground, was not for sale.

Mary Dod Brown Chapel, Lincoln University. *Author's collection.*

A prolonged legal battle punctuated with physical confrontations ensued. In 1888, the Wallses' ancestral church became affiliated with the AUMP denomination, thereafter called Hosanna AUMP. In 1889, the sellout faction won the funds initially raised and built its own church, AME Zion, a half mile away on Ashmun Road on a lot purchased from Lincoln. By 1896, the Walls family church had been torn down and rebuilt into the current brick structure.[254]

The last of the Hinsonville men to enlist, Charles was also the last to die, succumbing to heart disease on January 28, 1923, at the age of seventy-six years, five months and fourteen days. Buried on the west side of the Hosanna Cemetery, his headstone is readable, marked with a GAR medallion and periodically decorated with a U.S. flag.

Bertha filed a pension claim on February 7, 1923, which was paid. By 1930, she was renting a house in Lower Oxford and working as a servant for a private family. She married Amos Lemons, a laborer with two years of elementary school education, and moved to West Chester. Their annual household income in 1940 was $529. Her son Fred roomed with them and earned $601 yearly working as a laborer for the Works Progress Administration. Bertha died that December from cancer of the brain and pancreas and was buried at Hosanna, probably near Charles in what is now an unmarked grave.[255]

Fred or his descendants placed the modern, sleek black granite headstone at Charles's grave that is now fallen and partly buried. This record of their forefather's heroic service reads:

C. WILLIAM COLE
MEMBER of CO. A
U.S.C. INF.
DIED JAN. 23, 1923

EPILOGUE

"The Lord Is a Man of War"

Dr. H.M. Turner, our Publisher, delivered a sermon before the Grand Army of the Republic, at the Cherry St., Baptist Church, in this city last Sunday afternoon. The exercises were impressive, and the remarks of the Doctor elicited much attention. The text was from Exodus XV:3: "The Lord is a man of war."
Christian Recorder, *May 24, 1877*

Addressing fellow veterans in Philadelphia, Henry McNeal Turner, who had served as the first black chaplain for the United States Colored Troops, was speaking to the proverbial choir. Incensed by the accelerating violence and discrimination against blacks, Turner and those who had fought both on the battlefield and as activists to gain full rights as citizens were still fighting for equality. For them, and most black Americans, spiritual and political war were inseparable. "The same old dogmas and prejudices of the now defunct institution of slavery meet us at every step and with all the greater fierceness," said an organizer of the 1867 Colored Soldiers and Sailors Convention held in Philadelphia.[256] "This prejudice has made an impassable gulf between the black soldier and sailor and his rights as such." This and future conventions raised concerns and proposed actions to address pensions, resources for orphans of war veterans and voting rights, among myriad issues.

The union was still racially divided and hostile. Black Americans faced discrimination in most areas of their lives, including public transportation and accommodation. A steamship captain in 1868 assaulted soldier-turned-

teacher Robert Fitzgerald as he headed to his new job in North Carolina. Accusing him of not having proof of paid fare, the captain spewed racist epithets at him, tried to rob him, forced him off the ship and encouraged bystanders to attack him. Robert described the incident as an example of race-tinged encounters he experienced or witnessed after the war:

> *I said, "Captain you have treated me like a dog; you have ordered me from the saloon; you will not have an enquiry made for the papers which I am sure one of your passengers must have; you treat me as though I was not a man because I am colored. And now sir you can put [me] ashore, I will not pay my passage twice."*[257]

The 1867 ruling of the public accommodation case William Still and other Philadelphians filed against the North Pennsylvania Rail Road found that black passengers could rightfully ride inside of public streetcars. This victory for civil rights was soon sullied when, in 1871, a white political operative gunned down black activist Octavius Catto as he headed to vote.

Having fought a war intended to improve their lives, black veterans continued to struggle for equitable compensation for injuries and diseases they incurred during that war. Nearly 179,000 black men fought in forty-one major battles and 449 in minor engagements; almost 37,000 died to restore the Union and destroy slavery,[258] Albert Walls and Hugh Hall among them.

In undoubtedly painful irony, while trying to secure pensions for declining health, largely due to war injuries and diseases, many of the sixteen Hinsonville soldiers who returned witnessed discrimination against black men at the institution that had sprung up from within their village: Lincoln University. Legendary Underground Railroad leader William Still, who attended graduation ceremonies from 1866 through the 1880s and whose son William Wilberforce Still attended and graduated from Lincoln, watched dismayed as the institution founded to train black male leaders rebuffed student and alumni pleas for black professors to be hired. Classmate of the younger Still and 1870 graduate Francis Grimke declared that "Lincoln University alone of Negro institutions shuts colored men out of its trustee Board and out of its professorships"[259] and launched a decades-long boycott of graduation ceremonies. His ally Frederick Douglass, who had attended antislavery meetings nearby and at Hosanna, joined Lincoln alumni in challenging the university's refusal to hire black faculty members. He said:

I am...entirely with you in your effort to counteract the tendency in colored institutions...to repress and discourage the colored man's ambition to do and to be something more than a subordinate when he is qualified to occupy superior positions. It is a part of the old spirit of caste, a legacy left us by slavery, against which we have to contend, and it is all the more difficult to meet because in colored institutions under white control where it is usually the guise of religion, and a pious regard for the happiness of the objects of its disparagement....But what more can we expect of the children of those who have for ages degraded and enslaved us? [260]

The institution Hinsonville residents had helped establish and to which they looked for moral instruction mirrored the bias they encountered in seeking fair consideration of pension claims. They felt betrayed by the community and country for which they had risked their lives and health. The Hinsonville cases show the cumbersome, exhausting process of applying for pension benefits.

The average monthly pension for a disabled Union private was eight dollars and increased over time with changes in pension laws. But Hinsonville veterans seem to have struggled for longer periods to receive payments equal to their white counterparts. Like all applicants, they provided information about their military service, disabilities and illnesses incurred during service and details of their personal lives. But in some cases, they were expected to provide information not feasible or possible due to extenuating circumstances, like Stephen Ringgold and George Duffy, who were born enslaved in Maryland, instructed to verify their birthdates and places, or Samuel Blake, who produced witnesses to his injuries, not recorded as having been treated in regimental hospitals—not an uncommon occurrence for black soldiers. While the pension claim process was purportedly colorblind, "ultimately the fate of black veterans' applications was decided by white bureaucrats who found it easy to turn them down without fear of retribution."[261] Even some of the examining physicians seemed reticent, if not negligent, in properly diagnosing the illnesses the men reported. Amos Hollingsworth was treated for years for diarrhea that steadily evolved into terminal stomach cancer.

The high financial stakes, both for veterans and lawyers familiar with the pension policies and laws, spurred a cottage industry for men like Theodore Stubbs of Oxford, Pennsylvania, who filed most of Hinsonville veterans' claims—even one for George Jay, who at the time was a permanent mental hospital patient diagnosed with incurable dementia. Stubbs had counterparts who specialized in claims for pensions and

bounties, the latter of which were not fully paid to many black enlistees. One such attorney advertised regularly: "I make a specialty of colored claims for bounty and pensions, and will persecute the same for the fee allowed by the Government," claimed John C. Bender.[262] It is unclear if all Hinsonville men received their promised bounties.

The GAR advocated for blacks to receive pensions equitable to white veterans, pushing for the eventual approval of the 1890 Dependent Pension Act, which expanded coverage to all veterans who were disabled and unable to do manual labor, even if disabilities were not direct results of the war. This enabled most of Hinsonville's aging veterans to partially support themselves, although most died in or near poverty and left widows who mostly subsisted as domestics. The revised law enabled Robert Fitzgerald, who became totally blind, to secure a pension to support himself. But Samuel Blake and George Jay never received any pension or remuneration for injuries they reportedly incurred during their service.

Chester County's racially segregated GAR chapters mirrored the paradoxical divide of America between men who had fought side by side to unify their country. *Smithsonian Magazine* recently published an article, "What Did the Rebel Yell Sound Like?," with a 1930 recording of former Confederate soldiers cheerfully demonstrating their rallying call.[263] Perhaps the more poignant question was posed in 1901, when poet Charles Chesnutt, known for exploring the racial and social complexities of post–Civil War America, wrote a tribute to veterans capturing issues that continued to undergird the twentieth-century struggle for a unified America. His "To the Grand Army of the Republic" in part noted:

> *When you went forth with weapons in your hands, Was it for gold, for vengeance, or for glory, The loud acclaim, the toast, the song, the story, That you went bravely forth in serried bands, Grand old men of the Grand Army?*
> *We know 't was not for one or all of these;*
> *'T was not by glory's glitter you were tempted;*
> *'T was not for wealth's allures your veins were emptied; You had no heaped-up hatreds to appease, Grand old men of the Grand Army!*
> *You fought for Union and for liberty, You gave your lives to save the threatened State, Which needed freedom to be truly great, Which needed union, to be surely free, Grand old men of the Grand Army!*[264]

Notes

Introduction

1. Chester County Historical Society Newspaper Clippings File.
2. Ibid.
3. Tillman Valentine's Civil War letters divulge details about his life and family relationships in Jonathan W. White, Katie Fisher and Elizabeth Wall, "The Civil War Letters of Tillman Valentine, Third US Colored Troops," *Pennsylvania Magazine of History and Biography* 139, no. 2 (2015): 171–88. Sarah Ann Burton, a white woman born in Delaware, married Thomas Fitzgerald, a formerly enslaved mulatto. The couple raised their children, including Robert G. Fitzgerald, in Hinsonville. Her sisters Mary Jane and Elizabeth Burton married mulatto Valentine brothers of Wilmington, including Tillman Valentine Sr., making Tillman Jr. and Robert G. Fitzgerald first cousins.
4. An early landowner, Edward Walls in 1851 deeded half an acre to the trustees of the First Colored Methodist Church (later Hosanna AUMP) for a cemetery for use by "his relatives as likewise any other persons of Colour" connected with the church. Chester County Office of the Recorder of Deeds, Deed Book I, 210–12.
5. John Miller Dickey, "Ethiopia Shall Soon Stretch Out Her Hand Unto God, Outlines of a Sermon Delivered in the Presbyterian Church in Oxford, Pennsylvania, 1853," Langston Hughes Memorial Library Special Collections and Archives, Lincoln University. Dickey's sermon

asserted: "The colored people of this country seem to have been sent here by Divine Providence that they might be Christianized and employed as laborers for the evangelization of Africa" and intended to justify the founding of Ashmun to train black male missionaries for work on the continent.

6. Addressing Lincoln alumni, including some who were raised in Hinsonville and nearby communities, Dickey asserted: "My friends you need all the results of the 100's of years which have accumulated within the white race. It is no fault of yours that you are far back in education, in science, in wealth, in power over the people of the world; you have had no opportunity, you are just emerging from a sleep of ages and you are nobly grasping the means offered you of placing yourselves on a high plane.... You desire the best instructor (s)... whose very presence with you and daily intercourse in the class room and the pulpit and in social intercourse will bring you up to their level. You are eager to learn; all your future that is of any value depends upon it and why should we now leave you and throw you upon the teaching of your own people? Wait: the time will come, but you may see the propriety of waiting longer than you may sometimes suppose necessary. High culture in a people is not the work of a day, get all you can from the best sources and let not pride rob you of success." John Miller Dickey Notebook, 1873, Langston Hughes Memorial Library Special Collections and Archives, Lincoln University.

7. Gooch, "Divine Providence."

8. Gooch, *On Africa's Lands: The Forgotten Stories of Two Lincoln Educated Missionaries in Liberia*; Russo and Russo, *Hinsonville*.

9. "Colored Soldiers' and Sailors' Convention," *Christian Recorder*, January 12, 1867.

10. Frederick Douglass, "Address of Hon. Fred. Douglass, Delivered before the National Convention of Colored Men, at Louisville, Ky., September 24, 1883," Colored Conventions, accessed October 26, 2016, coloredconventions.org/items/show/554.

11. In a letter to Isaac N. Rendall on March 21, 1911, Christian humorously recalled that his instruction "calmly and conclusively settled many devotional points which had puzzled older minds for centuries." Langston Hughes Memorial Library Special Collections and Archives, Lincoln University.

12. *History of Churches and Worship Groups in the Oxford Area* (Oxford, PA: Oxford Area Historical Association and Book Committee, 2012); Historical Atlas of Chester County, Pennsylvania, Chester County Planning Commission,

West Chester, PA, 1998; *Around the Oak: Oxford, Pennsylvania* (Oxford, PA: Friends of the Oxford Public Library, 1999).

13. John W. Brown Diary, *U.S. Colored Trooper, 1863*, George and Portia Walls, private collection.

Chapter 1

14. Ibid.

15. Born in 1776, Patrick appears as a free man in the 1820 census, as does his son George, suggesting both were freed earlier. Patrick's son Edward was manumitted in 1794 and was the first of the Walls family to begin purchasing land in Hinsonville in 1829. Russo and Russo, *Hinsonville*, discusses Walls landownership further.

16. Records of the Fifty-Fourth Massachusetts Infantry Regiment (Colored), 1863–1865, fold3.com; Luis Emilio, *History of the Fifty-Fourth Regiment of Massachusetts Volunteer Infantry, 1863–1865* (New York: Johnson Reprint Corporation, 1968), 9.

17. Emilio, *History*, 9.

18. George E. Stephens, letter to editor, *Weekly Anglo-African*, July 21, 1863, in Yacovone, *Voice of Thunder*, 245.

19. *De Nyew Testament in Gullah Sea Island Creole* (New York: American Bible Society, 2005).

20. Records of the Fifty-Fourth Massachusetts Infantry Regiment, 22.

21. Meg Daly Twaddell, *Inns, Tales and Taverns of Chester County* (N.p.: Country Publications, 1985): 150–57.

22. William Jay Statement, Declaration for Increase, December 28, 1892, Pension Application File, National Archives and Records Administration (hereafter NARA).

23. Ibid.

24. September 21, 1875 Surgeon's Certificate, William Jay Pension Application File.

25. William Jay Statement to Attorney Theodore K. Stubbs, Declaration for Increase, January 16, 1885, William Jay Pension Application File.

26. Chester County Historical Society Newspaper Clippings File.

27. Ibid.

28. Ibid.; Chester County, Pennsylvania Proof of Death Registers, 1875–1893; Chester County, Pennsylvania Wills and Administrations, 1714–1900. Although Joshua Jay's death is officially reported as 1885, the 1880

census lists Lydia as widowed. Joshua probably died at home and his death was later recorded when the property transfer to William occurred.

29. Declaration of Increase Statement, April 21, 1888.

30. Ibid.

31. He was related through his mother, Sarah Jay, who may have been Joshua Jay's sister; Declaration for Increase Statement, December 10, 1888.

32. Chester County, Pennsylvania Wills and Administrations, 1714–1900.

33. Ibid.

34. William Jay Pension Application File; Pennsylvania, Death Certificates, 1906–1964; 1920 U.S. Federal Census; findagrave.com. The abandoned, former African Union Church Hill cemetery contains graves of several USCT members.

35. Sue Eisenfeld, "The Birth of Civil War Reenacting," *New York Times*, January 8, 2015, https://opinionator.blogs.nytimes.com/2015/01/08/the-birth-of-civil-war-reenacting.

36. "The Work of the Civil Rights Convention," *Christian Recorder*, December 18, 1873.

37. Wesley Jay Statement, October 25, 1881, Pension Application File, NARA.

38. "Congress and the Pay of Colored Troops," *Christian Recorder*, April 16, 1864.

39. "Army Correspondence," *Christian Recorder*, June 25, 1864.

40. Ibid.

41. Ibid.

42. William Walls Affidavit, February 18, 1890.

43. Wesley Jay Disability Affidavit, November 13, 1879; Examining Surgeon's Certificate, August 11,1880.

44. Records of the Fifty-Fourth Massachusetts Infantry Regiment; Emilio, *History*, 346.

45. Jane Jay Application for Accrued Pension, July 28, 1903.

46. Ibid.

47. Jane Jay letter to Commissioner of Pensions, August 4, 1926, and Commissioner of Pensions Winfield Scott letter to Jane Jay, October 8, 1926.

48. Chester County Historical Society Newspaper Clippings File.

49. "Pennsylvania, Death Certificates, 1906–1964," ancestry.com.

50. Chester County Historical Society Newspaper Clippings File.

51. Prison Administration Records, Warden's Daily Journals, 1829–1961, Eastern State Penitentiary, Pennsylvania State Archives, Harrisburg.

52. Descriptive Registers 1875–1884, 1875–1888, Eastern State Penitentiary, Pennsylvania State Archives, Harrisburg.

53. Discharge Description Docket 1873–1890, Eastern State Penitentiary. Pennsylvania State Archives, Harrisburg; Warden's Daily Journals, January 19, 1887. The controversial Philadelphia case that precipitated the new law is examined in James R. Wright Jr.'s article, "The Pennsylvania Anatomy Act of 1883: Weighing the Roles of Professor William Smith Forbes and Senator William James McKnight," *Journal of the History of Medicine and Allied Sciences* 71, no. 4 (2016): 422–46.

54. Quarter Sessions Docket and Papers, October 1873–August 1879, Chester County Archives and Record Services, West Chester, Pennsylvania.

55. Ibid.

56. Ibid.

57. Ibid.

58. Norman Bruce Johnston, Kenneth Finkel and Jeffrey A. Cohen, *Eastern State Penitentiary: Crucible of Good Intentions* (Philadelphia: Eastern State Penitentiary Historic Site, 2010); *Eastern State Penitentiary Historic Structures Report*, vol. 1, City of Philadelphia Historical Commission and Eastern State Penitentiary Task Force of the Preservation Coalition of Greater Philadelphia, July 21, 1994, http://www.easternstate.org/learn/research-library/history/571-page-history.

59. Warden's Daily Journals, October 25, 1882.

60. Ibid., March 18, 1883.

61. Ibid., May 17, 1884.

62. Ibid., June 4, 1884.

63. Ibid., June 5, 1884.

64. Ibid., June 11, 1884.

65. Ibid., July 3, 1884.

66. Ibid., June 7, 1886.

67. Ibid., August 18, 1883.

68. Ibid., July 4, 1884.

69. Ibid., January 24, 1885.

70. Ibid., January 18, 1885.

71. Ibid., May 1, 1887.

72. Chester County Poorhouse Admission Books, 1800–1910, http://www.chesco.org/1711/Poorhouse-Records-1800-1910.

73. Ibid.

74. Pennsylvania Marriages, 1709–1940, familysearch.org.

75. Declaration for Invalid Pension, August 27, 1895, George Jay Pension Application File, NARA.

76. Emery A. Wilson Affidavit, November 24, 1897.

77. Surgeon's Certificate, June 18, 1897.
78. George Jay Death Certificate, Pennsylvania Death Certificates, 1906–1963, ancestry.com. Embreeville County Home began as the county almshouse in 1798. By 1900, patients from Norristown State Hospital had been relocated to Embreeville Asylum, which was later remodeled into an expanded medical center.
79. Chester County Historical Society Newspaper Clippings File. According to his death certificate, Joshua died on October 27, 1911, from a blood clot and had been hospitalized for two weeks. He was thirty-nine years, seven months and twenty-six days old. Joshua Jay Death Certificate, Pennsylvania Death Certificates, 1906–1963, ancestry.com.
80. James Cole Pension Application File, NARA.
81. Declaration for Original Invalid Pension, February 6, 1879, James Cole Pension Application File, NARA.
82. John Shirley Statement, March 2, 1882, James Cole Pension Application File, NARA.
83. Invalid Claim for Pension Increase, April 13, 1892, James Cole Pension Application File, NARA.
84. James Cole Statement, May 4, 1898, James Cole Pension Application File, NARA.
85. Pennsylvania, Death Certificates, 1906–1964.
86. When applying for a widow's pension, Harriet provided a copy of their certificate of marriage, which stated that Samuel O. Wood, minister of the gospel, conducted the ceremony.
87. John Shirley Affidavit, March 27, 1888.
88. Ibid., April 15, 1888.
89. Enos Spriggs Affidavit, July 15, 1889.
90. Census and family Bible records show five children born to the couple between 1886 and 1896, including Ella, Elijah, Elias and James. Josiah Cole Pension Application File, Pennsylvania, Veterans Burial Cards, 1777–2012, ancestry.com.

Chapter 2

91. Robert G. Fitzgerald Diary, Pauli Murray Papers, 1827–1985, Schlesinger Library, Radcliffe Institute, Harvard University, Cambridge, Massachusetts.

92. "Interior Department Names Pauli Murray House a National Historic Landmark," Duke Today, accessed July 5, 2017, https://today.duke.edu/2017/01/interior-department-names-pauli-murray-house-national-historic-landmark.

93. Black abolitionist William Parker was acquainted with Hinsonville residents. He discussed the 1851 events said to be the first resistance to the 1850 Fugitive Slave Law. "The Freedman's Story: In Two Parts," *Atlantic Monthly*, accessed July 19, 2017, http://docsouth.unc.edu/neh/parker1/parker.html.

94. Murray, *Proud Shoes*, 94–95.

95. Ibid., 99–100. Quaker Charles Hambleton was among area residents who operated Underground Railroad stations listed in Kashatus, *Just Over the Line*, 94–96. The antislavery activism of Charles and his brothers Eli and Thomas and other family members is examined in Bond, *Education for Freedom*, 197.

96. "Addresses of the Hon. W.D. Kelley, Miss Anna E. Dickinson and Mr. Frederick Douglass: At a Mass Meeting, Held at National Hall, Philadelphia, July 6, 1863, for the Promotion of Colored Enlistments," in *Frederick Douglass Selected Speeches and Writings*, ed. Philip S. Foner and Yuval Taylor (Chicago: Lawrence Hill Books, 2000), 537.

97. Robert Fitzgerald Diary, May 6, 1864.

98. Ibid., May 7, 1864.

99. Ibid., May 21, 1864.

100. Ibid., May 25, 1864.

101. Ibid., June 10, 1864.

102. Ibid., June 16, 1864.

103. Ibid.

104. Ibid., July 26, 1864.

105. Certificate of Disability for Discharge, October 4, 1864, Robert G. Fitzgerald Pension Application File, NARA.

106. "Oxford Correspondence," *Christian Recorder*, December 3, 1864.

107. "A Testimonial of Respect," *Christian Recorder*, December 31, 1864.

108. "The Celebration of Lincoln University," *American Republican*, July 3, 1866; 1853–1874 Newspaper Clippings of Ashmun Institute and Lincoln

University, accessed July 4, 2017, http://contentdm.auctr.edu/cdm/compoundobject/collection/lupa/id/2044/rec/1.

109. Robert G. Fitzgerald Letter to Isaac Rendall, August 25, 1866, Pauli Murray Papers.

110. Ibid.

111. Ibid.

112. Ibid.

113. Ibid.

114. Robert Fitzgerald Diary, June 29 and July 17, 1867.

115. Ibid., October 13, 1867.

116. Ibid., September 21 and September 22, 1867.

117. Ibid., September 22, 1867.

118. Ibid., October 7, 1867.

119. Ibid., November 23, 1867.

120. Ibid., October 6, 1868.

121. Robert G. Fitzgerald Affidavit, November 4, 1882.

122. Murray, *Proud Shoes*, 57.

123. Investigator Letter to Secretary of the Interior, August 14, 1890, Robert G. Fitzgerald Pension File.

Chapter 3

124. J. Mason Brewer, *Dog Ghosts and Other Texas Negro Folk Tales* (Austin, TX: University of Texas Press, 1976), 50. Brewer combines two original volumes of black Texan folklore he collected representing the region's dialect. The Brazos River covers nearly 1,300 square miles and is often used to mark the boundary between east and west Texas.

125. Samuel Henry Blake Affidavit, July 23, 1881; Isaac Amos Hollingsworth Affidavit, July 25, 1881; Amos Daws Pension Application File, NARA.

126. Theodore A. Worrall Examining Surgeon's Certificate, September 7, 1881, Samuel H. Blake Pension Application File.

127. Compiled Military Service Records of Volunteer Union Soldiers Who Served the United States Colored Troops: Miscellaneous Personal Papers, NARA; 1860, 1870, 1880 U.S. Federal Census; Stephen Butcher Affidavit, December 2, 1892. Neighbor and family friend Stephen Butcher provided a statement in support of Samuel's second wife Rebecca's application for a widow's pension. Stephen says he attended the funeral and burial service for Margaret Blake at Hosanna Church in August 1875.

128. Theodore K. Stubbs letter to Pension Commissioner O.P.G. Clark, November 4, 1884.

129. Samuel H. Blake Affidavit, November 24, 1884.

130. Henry Carl Affidavit, April 17, 1884.

131. Amos Daws Affidavit, May 16, 1884; Amos Daws Affidavit, July 3, 1885.

132. Amos Daws Affidavit, July 3, 1885.

133. Samuel H. Blake letter to Pension Commissioner Wm. E. McLean, October 1, 1885.

134. Theodore K. Stubbs letter to Wm E. McLean, Acting Commissioner, October 15, 1885.

135. Amos Hollingsworth Deposition, January 9, 1886.

136. Ibid.

137. Ibid., March 10, 1886.

138. Stephen Ringgold Deposition, May 5, 1886.

139. Ibid.

140. W.C. Powell, MD, Deposition, May 10, 1886.

141. Charles Mays, Special Examiner, May 10, 1886 letter to Hon. John C. Black, Commissioner of Pensions.

142. Ibid.

143. "Chester County Poorhouse Admission Books, 1800–1910," accessed March 28, 2016, http://www.chesco.org/1711/Poorhouse-Records-1800-1910.

144. Rejection of Appeal of Original Invalid Pension, March 17, 1891.

145. Commissioner, Department of the Interior Bureau of Pensions, July 1, 1898 rejection letter to Rebecca Taylor.

146. Pennsylvania, Death Certificates, 1906–1964, ancestry.com.

147. Amos Hollingsworth Affidavit, July 25, 1881, Amos Daws Pension Application File, NARA.

148. Ibid.

149. Amos Daws General Affidavit, July 15, 1882.

150. Ibid.

151. Amos Daws Disability Affidavit, July 18, 1881.

152. Amos Daws General Affidavit, July 15, 1882.

153. Ibid.

154. Annie E. Daws Declaration of Widow's Pension, October 29, 1890.

155. Ibid.

156. Ibid., 1870, 1880 U.S. Federal Census.

157. Ida Kyle Deposition, April 5, 1889.

158. James Hutchinson Statement, April 22, 1889.

159. Amos Hollingsworth Deposition, March 26, 1889. Amos was likely related to Annie, whose maiden name was Hollingsworth. She and Amos had lived in the same East Nottingham neighborhood as youngsters.

160. Annie E. Daws Declaration of Widow's Pension; Rejection of Widow's Pension, November 8, 1892.

161. Lydia A. Hickman Statement, April 22, 1889.

162. Pennsylvania, Philadelphia City Death Certificates, 1803–1915, familysearch.com.

163. George Birdsall Passmore was the son of Andrew and Judith Passmore, members of the Nottingham Monthly Meeting. In 1860, he lived with his parents and siblings in East Nottingham near Amos Hollingsworth's family. Passmore later worked as a lumber dealer in Oxford and eventually moved to Calvert, Cecil County, Maryland. Annie (Hollingsworth) Daws, who also lived in Calvert for a while, and was likely related to Amos, kept in touch with George Passmore until his death in Calvert in 1890. Evidently, the Hollingsworth family had a long-standing relationship with the Passmores.

164. Robert P. Dubois certified on April 5, 1908, as evidence of marriage to support Mary Jane Hollingsworth widow's pension application. Dubois was a member of Lincoln University's Board of Trustees.

165. 1840, 1850, 1830, 1880, 1900 U.S. Federal Census. The 1880 census Upper Oxford record describes Amos, his wife and children as mulatto. Glendeur may be the Isaac G. who appears in the 1900 census living with his parents: Anias (Amos) Hollingsworth, thirty-year-old mulatto. Birthplace: MD, 1850. Occupation: farmhand. Cannot read. Cannot write. Birthplace of mother: MD. Birthplace of father: MD. Mary J. twenty-eight, wife, mulatto. Birthplace: VA. Glendeur 9, son, mulatto. Clarissa, 7 daughter, mulatto. Anna L., 5 daughter, mulatto. Willie, 2, daughter, mulatto.

166. Isaac Amos Pension Claim, October 14, 1891, Pension Application File, NARA.

167. September 5, 1894 filing.

168. The February 19, 1895 Disability Affidavit is notarized by D.A. Stubbs.

169. Surgeon's Certificate, May 28, 1902; Surgeon's Certificate, December 16, 1903; Invalid Pension Claim, May 15, 1905.

170. Mary Jane Hollingsworth Widow's Application, November 15, 1906.

171. Physician's Affidavit, December 5, 1906, provided to support Mary Jane's widow pension claim.

172. Find A Grave Index, familysearch.com.

Chapter 4

173. Scott, "The 41st United States Colored Troops: 'We Did Not Falter,'" in *Camp William Penn: 1863–1865*, 242.

174. Ibid.

175. Murray, *Proud Shoes*, 220.

176. 1860 United States Federal Census, Wilmington Ward 1, New Castle, Delaware; U.S. Civil War Draft Registrations Records, 1863–1865, ancestry.com; familysearch.org; U.S. Colored Troops Military Service Records, 1863–1865, fold3.com.

177. Murray, *Proud Shoes*, 226.

178. 1870 U.S. Federal Census, Lower Oxford, Chester County, Pennsylvania; 1880 U.S. Federal Census, Philadelphia, Pennsylvania, House of Refuge Colored Department; Cecile P. Frey, "The House of Refuge for Colored Children," *Journal of Negro History* 66, no. 1 (1981): 19.

179. U.S. City Directories, 1882–1995; Philadelphia, Pennsylvania, City Directory, 1884, 1885, 1887, 1888; 1890 Veterans Schedules, Philadelphia, Pennsylvania, ancestry.com; W.E.B. Du Bois, *The Philadelphia Negro* (New York: Lippincott, 1899), 287–21; Pennsylvania, Philadelphia City Death Certificate, 1893–1915, ancestry.com.

180. William Still, *Still's Underground Rail Road Records* (Philadelphia: William Still, 1886), xxxiv. In "The Curious Case of Body Snatching at Lebanon Cemetery," Erin McLeary summarizes the parties involved and the 1882 investigations prompted by the *Philadelphia Press* observations of the clandestine activities, accessed June 14, 2017, http://hiddencityphila.org/2015/04/the-curious-case-of-body-snatching-at-lebanon-cemetery. The *Christian Recorder* closely covered the scandal, observing on December 7, 1882, "As we go to press, our city is stirred to its very center by the wholesale stealing of the dead from Lebanon Cemetery. It is to be hoped that the law authorities will search the whole affair to its very depths and allow none who in any way profited by the sacrilege to escape." This long-standing practice of grave robbing prompted the 1883 passage of Pennsylvania's Anatomy Act, which permitted the statewide distribution of unclaimed bodies for dissection.

181. Letter to First Deputy Commissioner, U.S. Pension Office, Abraham Stout Pension Application File, NARA.

182. Ibid.

183. Ibid.

184. 1850, 1860 United States Federal Census; U.S. Colored Troops Military Service Records, 1863–1865, fold3.com; U.S. Civil War Draft Registrations Records, 1863–1865, ancestry.com; familysearch.org.

185. Chester County Historical Society School Records Collection, MS.105; Abraham Stout letter to First Deputy Commissioner.

186. August 31, 1909, Chester County Historical Society News Clippings File.

187. Ibid.

188. Ibid.

189. 1880 U.S. Federal Census; 1890 U.S. Federal Civil War Veterans Census; 1900, 1910 U.S. Federal Census.

190. Find A Grave Index, familysearch.org.

191. History of Claim, 1899–1900, Abraham Stout Pension Application File, NARA.

192. Pennsylvania, Death Certificates, 1906–1964; 1920 U.S. Federal Census.

193. Pennsylvania, Veterans Burial Cards, 1777–2012, ancestry.com.

Chapter 5

194. "Letter from 25th USCT," *Christian Recorder*, February 18, 1865; Scott, "The 25th United States Colored Troops: 'Disease Had Run Its Course,'" in *Camp William Penn*, 224–32; Samuel Penniman Bates, *History of Pennsylvania Volunteers, 1861–5: Prepared in Compliance with Acts of the Legislature*, vol. 5 (Harrisburg, PA: B. Singerly, State Printer, 1869–71).

195. "Letter from 25th USCT."

196. "Florida Correspondence," *Christian Recorder*, December 3, 1864.

197. 1850, 1860 U.S. Federal Census.

198. Company Descriptive Book of 25th Regiment, U.S. Colored Infantry, NARA; Compiled Military Service Records of Volunteer Union Soldiers Who Served with the United States Colored Troops: Infantry Organizations, 20th through 25th, NARA; Case Files of Approved Pension Applications of Widows and Other Dependents of Civil War Veterans, 1861–1910, NARA, fold3.com; ancestry.com.

199. *Bethel African Methodist Episcopal Church History 1911–Present*, a privately printed historical booklet in the archives of the church.

200. Lewis Ringold Pension Application File, NARA, February 16, 1867.

201. Lewis Palmer statement.

202. Company Descriptive Book of 25th Regiment.

203. "Oxford Circuit," *Christian Recorder*, August 26, 1865.

204. Hutchinson Affidavit, Widow's Pension Claim, October 20, 1874.

205. Ringold Pension Application, 1867.

206. Hutchinson Affidavit, 1874.

207. Chester County Poorhouse Admission Records 1800–1910, accessed August 1, 2016, http://www.chesco.org/1712/Admission-Books 1800-1910.

208. 1870 United States Federal Census; Chester County Poorhouse Admission Records.

209. Physician's Affidavit, July 5, 1902.

210. Declaration for Original Invalid Person, May 20, 1880.

211. Proof of Disability statement by Bond.

212. Proof of Disability statements by Butcher and Wilson.

213. Physician's Affidavit.

214. Ibid.

215. 1860 U.S. Federal Census; U.S. Federal Census Mortality Schedules Index, 1850–1880; Pennsylvania, Death Certificates, 1906–1964, familysearch.org.

Chapter 6

216. Bond, *Education for Freedom*, 197.

217. Scott, "The 22nd United States Colored Troops: 'Phase of Hellfire Baptism,'" in *Camp William Penn*, 198–223; "Funeral Ceremonies of Abraham Lincoln in Washington," *Christian Recorder*, April 22, 1865.

218. George W. Duffy General Affidavit, April 22, 1905, Pension Application File, NARA.

219. "For the Christian Recorder," *Christian Recorder*, October 15, 1864.

220. "Army Correspondence," *Christian Recorder*, September 24, 1864.

221. Declaration for Original Invalid, October 22, 1877.

222. Claimant Affidavit, September 8, 1904.

223. George W. Duffy General Affidavit, April 22, 1905. Duffy may have been referring to the Scotland tract that bordered the eastern portion of land surveyed and named for Benjamin Culver in 1754. The Scotland tract was near present-day Interstate 95 above Aberdeen.

224. Ibid.

225. U.S., Civil War Draft Registrations Records, 1863–1865; U.S. Colored Troops Military Service Records, 1863–1865, fold3.com; ancestry.com.

226. George W. Duffy Pension Application File.

227. 1870, 1880, 1900 U.S. Federal Census.

228. Physician's Affidavit, August 17, 1906, George W. Duffy Pension Application File.

229. Pennsylvania, Death Certificates, 1906–1964, ancestry.com; Assessor John G. Audresse statement, January 25, 1908.

230. *Vincennes (IN) Gazette,* January 14, 1860.

231. Reverend John Miller Dickey, Ashmun Institute's founder, appears to have been distantly related to Ebenezer, whose son Thomas B. Dickey knew Stephen Ringgold well and provided a statement supporting Stephen's 1887 pension increase claim. He had known Stephen for years and said "he was a stout, hardy fellow and able to do a good day's work before the war." Thomas B. Dickey General Affidavit, February 15, 1887.

232. 1840, 1850, 1860 U.S. Federal Census; Stephen J. Ringgold Pension Application File.

233. Bureau of Pensions Commissioner letter, August 6, 1907.

234. Ibid.

235. Stephen J. Ringgold statement, July 15, 1879.

236. Proof of Disability Statements, May 19, 1880, and June 3, 1880.

237. Ellis Watson statement, May 20, 1880.

238. William McCullough statement, March 12, 1881.

239. Stephen J. Ringgold statement, November 1, 1884.

240. Physician's Affidavit, January 6, 1885.

241. "A Fatal Accident," *Every Evening: Wilmington Daily Commerce,* January 9, 1903, 5, Delaware Historical Society; Delaware Death Records, 1811–1933, familysearch.org.

242. J.A. Watt Statement, May 24, 1912.

243. Pennsylvania, Prison, Reformatory, and Workhouse Records, 1829–1971; U.S. WWI Veterans Service and Compensation Files, 1917–1919, 1934, 1948, ancestry.com.

Chapter 7

244. U.S. Colored Troops Military Service Records, 1863–1865 for 24th U.S. Colored Infantry, fold3.com.

245. William Still, *A Brief Narrative of the Struggle for the Rights of the Colored People of Philadelphia in the City Railway Cars,* 1867, http://stillfamily.library.temple.edu/content/brief-narrative-struggle-right, accessed December 9, 2016.

246. "From Camp Wm. Penn," *Christian Recorder*, April 15, 1865.

247. Ibid.

248. "City Affairs," *North American*, April 15, 1865, excerpted from Harrower and Wieckowski, *A Spectacle for Men and Angels*, 318.

249. Special Order No. 27, April 21, 1865, NARA, and "City Affairs," excerpted from, Harrower and Wieckowski, *A Spectacle for Men and Angels*, 322; "Obsequies of the Late President, Abraham Lincoln," *The Philadelphia Press*, April 24, 1865, Camp William Penn Museum, La Mott, PA.

250. "From Camp Wm. Penn."

251. U.S. Colored Troops Military Service Records, 1863–1865 for 24th U.S. Colored Infantry; 1870, 1900 U.S. Federal Census; William Cole and Lucy Ann Cole Affidavit, March 30, 1903, Josiah Cole Pension Application File, NARA.

252. 1850, 1860 U.S. Federal Census.

253. Bertha is the daughter of John and Mary Lee and granddaughter of Rachel Wall, who married James Cole, the father of Josiah and John Cole, who served in the 54th, making Bertha their niece. A family relationship of Charles to the Cole brothers is not determined but probable; 1910, 1920 U.S. Federal Census; Pennsylvania, County Marriages, 1885–1950, familysearch.org.

254. Deed Book I-10, 210–12, and Deed Book P-10, 493, Office of the Recorder of Deeds, Chester County Archives; Chester County Historical Society Newspaper Clippings File.

255. 1930, 1940 U.S. Federal Census; Pennsylvania, Death Certificates, 1906–1964, ancestry.com.

Epilogue

256. "Colored Soldiers' and Sailors' National Convention," *Christian Recorder*, January 12, 1867.

257. Robert G. Fitzgerald Diary, September 22, 1868.

258. Glatthaar, *Civil War's Black Soldiers*. (Conshohocken, PA: Eastern National Park and Monument Association, 2016), 54.

259. Gooch, "Divine Providence," 137.

260. Frederick Douglass, "Caste in Colored Institutions," *Alumni Magazine* 1, no. 5 (1885): 124. Oral history holds that Douglass spoke at Hosanna. The Pennsylvania Historical and Museum marker in front of the church states that the church hosted him. The origin of the story of Douglass's visit may stem from his attendance of the 1844 meeting of the Clarkson Anti-

Slavery Society in Oxford on Saturday, August 24, which he described in a letter to a fellow abolitionist in Frederick Douglass, *The Frederick Douglass Papers. Series 3: Correspondence*, vol. 1, *1842–52*, ed. John R. McKivigan (New Haven, CT: Yale University Press, 2009), 28.

261. Kathleen L. Gorman, "Civil War Pensions," Essential Civil War Curriculum, accessed May 9, 2017, http://www.essentialcivilwarcurriculum.com/civil-war-pensions.html.

262. "Important to Colored Soldiers and Their Heirs," *Christian Recorder*, October 29, 1882. John C. Bender of St. Joseph, Missouri, advertised in the *Christian Recorder*, which was distributed nationally.

263. "What Did the Rebel Yell Sound Like," *Smithsonian Magazine*, accessed August 1, 2017, http://www.smithsonianmag.com/videos/category/3play_1/what-did-the-rebel-yell-sound-like.

264. Poems of the Charles Chesnutt Digital Archive, accessed August 1, 2017, http://www.chesnuttarchive.org.

Selected Bibliography

Bond, Horace Mann. *Education for Freedom: A History of Lincoln University.* Princeton, NJ: Princeton University Press for Lincoln University, 1976.

Gooch, Cheryl Renée. "By Divine Providence: Remembering Lincoln's Founding and Reimagining Its Legacy." In *Memory and the Poetics of Remembering,* edited by Abbes Maazaoui, 129–42. Newcastle upon Tyne, UK: Cambridge Scholars Publishing, 2016.

———. *On Africa's Lands: The Forgotten Stories of Two Lincoln Educated Missionaries in Liberia.* Lincoln University, PA: Lincoln University Press, 2014.

———. "On Africa's Lands: The Shared Humanitarian Heritage of Hosanna Church and Lincoln University." *Lincoln Journal of Social and Political Thought* 8, no. 2 (2013): 11–38.

Harrower, David I., and Thomas J. Wieckowski. *A Spectacle for Men and Angels.* West Conshohocken, PA: Infinity Publishing, 2013.

Kashatus, William C. *Just Over the Line: Chester County and the Underground Railroad.* West Chester, PA: Chester County Historical Society, 2002.

Murray, Pauli. *Proud Shoes: The Story of an American Family.* New York: Harper & Brothers, 1956.

Russo, Marianne H., and Paul A. Russo. *Hinsonville, a Community at the Crossroads: The Story of a Nineteenth-Century African-American Village.* Selinsgrove, PA: Susquehanna University Press, 2005.

Scott, Donald. *Camp William Penn: 1863–1865.* Atglen, PA: Schiffer Publishing, 2012.

Williams, George Washington. *A History of the Negro Troops in the War of Rebellion, 1861–1865.* New York: Fordham University Press, 2012.

Yacovone, Donald, ed. *A Voice of Thunder: A Black Soldier's Civil War. The Letters of George E. Stephens*. Urbana: University of Illinois Press, 1998.

Collections and Resources

Camp William Penn Museum and Interpretive Center
Charles L. Blockson Afro-American Collection, Temple University
Chester County Historical Society Newspaper Clippings File
Chester County Historical Society School Records Collection
Chester County USCT Index
The *Christian Recorder*
The Civil War's Black Soldiers, National Park Civil War Series, 2016
Compiled Military Records of United States Colored Troops 1863–1866, National Archives and Records Administration
Historical Society of Harford County, Maryland
Lincoln University Digital Collection, History Resources Online
Lincoln University HBCU Library Alliance Collection 1853–1973
Lincoln University Special Collections and Archives
Mütter Museum of the College of Physicians of Philadelphia permanent exhibition "Broken Bodies, Suffering Spirits: Injury, Death, and Healing in Civil War Philadelphia"
Oxford, Pennsylvania Library Company Historical Collection
Pauli Murray Papers, 1827–1985, Schlesinger Library, Radcliffe Institute, Harvard University
Petersburg National Battlefield, National Park Service
Wuanda M.T. Walls Family Papers, Historical Society of Pennsylvania

Index

About the Author

Cheryl Renée Gooch is an academic leader and published scholar with a passion for cultural history and uncovering aspects of African American history that are lost or forgotten. She is the author of *On Africa's Lands: The Forgotten Stories of Two Lincoln Educated Missionaries in Liberia* (Lincoln University Press, 2014), which chronicles the experiences of James Ralston Amos and Thomas Henry Amos, former Hinsonville residents. She is a lifetime member of the Association for the Study of African American Life and History and serves on its executive council.

Visit us at
www.historypress.net